CELTIC
ILLUMINATION

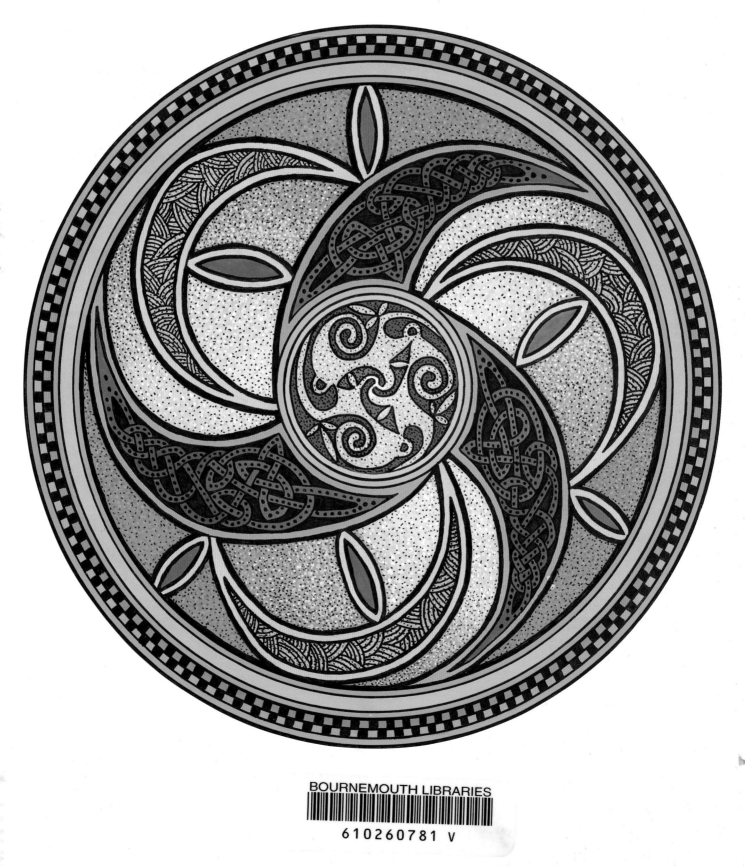

Dedicated to the memory of
Amanda Fearnhamm

To the Sacred Thread that binds us, and the
unseen helpers who guide my pen

CELTIC
ILLUMINATION

Courtney Davis

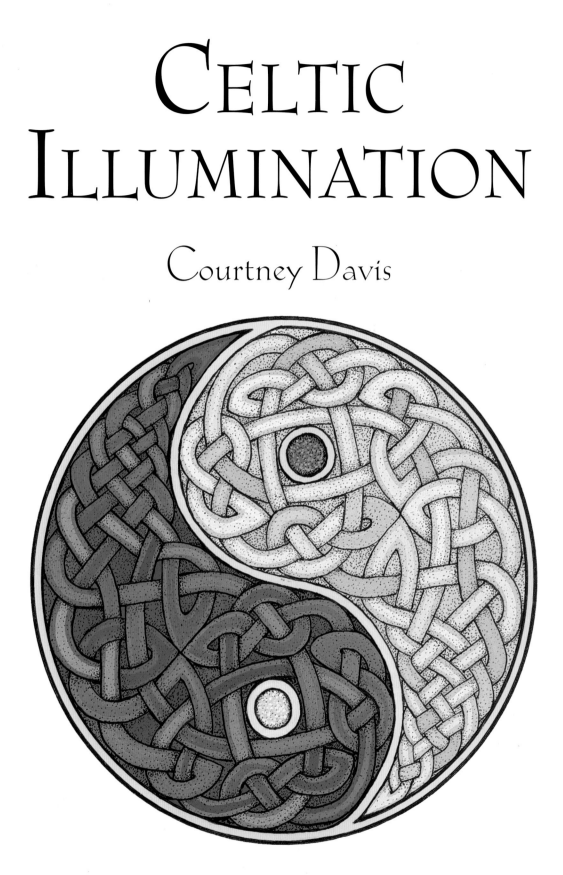

SEARCH PRESS

First published in Great Britain 2001

Search Press Limited
Wellwood, North Farm Road,
Tunbridge Wells, Kent TN2 3DR

Text and images copyright © Courtney Davis

Photographs by Search Press Studios

Photographs and design copyright © Search Press Ltd. 2001

ISBN 0 85532 931 9

The Publishers and author can accept no responsibility for any
consequences arising from the information, advice or instructions
given in this publication.

Readers are permitted to reproduce any of the patterns or designs in
this book for their personal use, or for the purposes of selling for
charity, free of charge and without the prior permission of the
Publishers. Any use of the patterns or designs for commercial
purposes is not permitted without the prior permission of the
Publishers.

Suppliers

If you have difficulty in obtaining any of the materials and
equipment mentioned in this book, then please visit the Search
Press website for details of suppliers: www.searchpress.com

Alternatively, you can write to the Publishers at the address above,
for a current list of stockists, which includes firms which operate a
mail-order service.

> **Publishers' note**
> All the step-by-step photographs in this book feature the
> author, Courtney Davis, demonstrating Celtic illumination.
> No models have been used.

Page 1: The Silent Mover
Page 3: Yin Yang

Colour separated by Regent Publishing Services Limited
Printed in Spain by Elkar S. Coop, 48180 Loiu (Bizkaia)

Courtney Davis was born in South Wales, but
grew up in London. It was his Welsh roots,
however, that inspired a passionate interest in
Celtic art. After a holiday trip to Wales he started
working on a series of Celtic designs – and has
ever since been inspired by the wonderful, intricate
patterns, pictures of historical manuscripts and
the art of the Celts. Now Courtney is a renowned
contemporary artist, and his insight into the
construction, balance and rhythm of the designs,
as well as the symbolism and historical
background has earned him worldwide recognition.

If you need any help with a design problem,
Courtney is happy to be contacted via his website
www.celtic-art.com

ACKNOWLEDGEMENTS

My thanks go to the staff at Search Press for
their excellent work; to David Elkington,
Shining Bear and Michael Ball for their support
and upliftment; and my long-suffering partner
Dimity and children Blaine and Bridie, who put
up with my lengthy periods of isolation while
creating these images.

CONTENTS

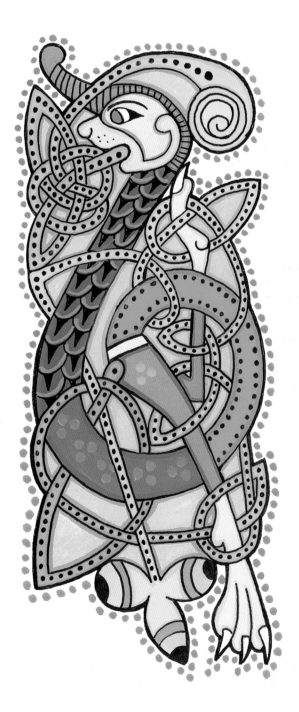

INTRODUCTION

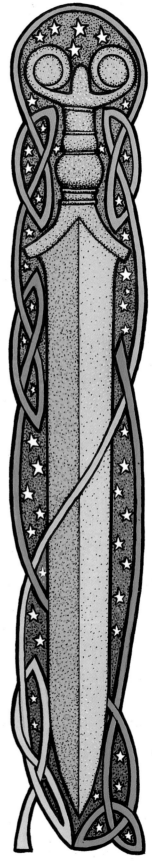

Celtic art has held a fascination for me for many years, but my true work began the moment I saw a shooting star pass through the Plough one night. I had asked Merlin for his help, and I took this as a sign that I had been granted his guidance. Since then, the stars and magic have never ceased.

With its strong symbology, potency and ancient power, true Celtic art really does affect the spirit of the artist and I have no doubts about the guidance and inspiration I have received, and still receive, for its creation.

Even after twenty years, with many hundreds of pictures behind me, I am amazed how much more I have still to learn. There is still a touch of magic associated with my work and I have always been mindful of the great privilege and the ability to bring light into people's lives through my art. For that I give thanks each and every day.

With each of my paintings I have questioned where on earth it was going, and whether it was worth continuing. I have only ever had to discard a few because they did not work, and I have learned that with perseverance, each picture comes to life as it is developed and my initial worries are soon forgotten.

The symbols which typify Celtic art had been used by different cultures for thousands of years before adaptation by the Celtic people. The barbarian people of Iron Age Europe were named *Keltoi* by the Greeks, but it is likely they thought of themselves as regional tribal groups rather than as a unified race. By the 6th century BC the Celts occupied the regions north of the Alps and the Upper Danube, later settling over much of Europe, as far east as Asia Minor.

The imagination and skill of the Celtic craftsmen took these symbols further, embellishing and creatin even more detailed and complex forms. Illuminated works such as the books of Kells and Durrow were the culmination of a long history of art.

The knotwork pattern is the most recognised form of the art, though it did not appear until late in Celtic history, and was used in its pure form for only a relatively short period. Most cultures have used some kind of interlaced design in decorative art, but the oldest surviving example is Chinese. Celtic knotwork symbolises infinity and the continuity of the spirit in this world and the next.

The circle or disc is considered to have been man's first step into art at the dawn of human intellect. It was seen in nature, in the constructions of animals, birds and insects. It also symbolised the sun and moon, male and female, heaven and earth.

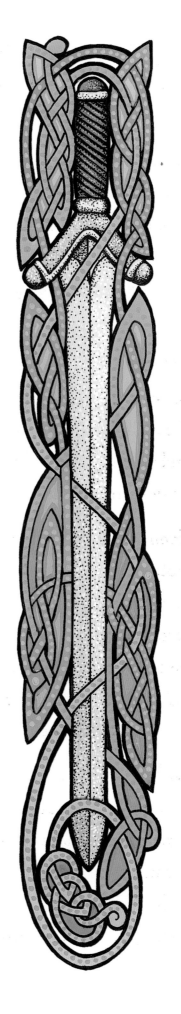

From the circle came the spiral, symbolising growth. The direction of its motion represented either positive (clockwise) or negative (counter-clockwise) attributes. Early Celts used the spiral to ornament scabbards, shields and other metalwork. Hair-spring spirals with tendrils and S-curves emerged during the 3rd century BC and by the 7th century AD, artists in Britain and Ireland were using four or more spiral coils. Examples can be seen in illuminated manuscripts as well as on cross slabs, high crosses and fine metalwork.

Key patterns have a long history and examples survive from as far back as 20,000–15,000 years BC. They evolved from spirals constructed with straight lines rather than curves. When connected, they formed complex labyrinths. Both key patterns and spirals are associated with protection and were often used to protect warriors, their weapons, homes and final resting places.

Zoomorphic ornament is based on the forms of animals, birds and reptiles. Its origins are the worship of animals and their power, and the earliest images are found in caves. It appears early in Celtic art but reached its height much later, as elaborate carvings on Pictish stone slabs and in illuminated books. Animals like the boar or stag represented the spirit of the forest and hunting, as well as prosperity and fertility. It was believed that the serpent – symbolising resurrection – regained its youth by shedding its skin.

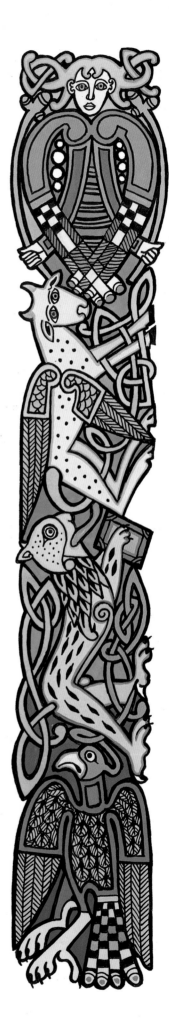

Knotwork was the last pattern to be used by monks, centuries after spirals and key patterns had been discarded. Influences from Scandinavia and Europe led to the decline of Celtic art and much of its meaning has been lost. It seems certain, however, that little of the ornamentation can be regarded as merely a pattern-filler.

In this book I have tried to show simple ways of creating knotwork, spiral, key and zoomorphic patterns. I am not mathematically-minded and find working with complex grids totally off-putting, so I may not have persevered enough with the mechanics. Thankfully, modern aids like tracing paper and light boxes make planning the work a bit easier, though it still takes time and the right frame of mind. One tip is to make a template which can be flipped or duplicated, yet will link effectively with the next panel.

I hope this book will prove a useful tool, bringing success, pleasure and satisfaction. At first the patterns may seem frustrating, but as with physical exercise, you must break through pain barriers. Once you reach the other side, the rewards are tremendous.

Remember you are drawing from powerful energies within and around each of us; be open and receptive to their influence and guidance. As you learn more about the subject, think of yourselves as chefs, creating wonderful recipes. The patterns are the ingredients you can combine to produce the final gourmet dish.

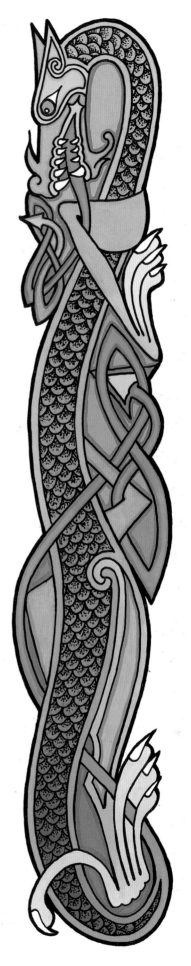

MATERIALS

These are the wands, potions and other ingredients with which to create your magic.
To capture memories of places and good times, I often use water from holy wells, rivers
or even pools formed in my garden. Always keep your tools clean; there is nothing more
annoying than marking the border of a picture with a dirty rule or inky fingers.

Paper I generally use A3 2-ply heavyweight paper to create finished work for books and product designs, as the surface gives a clean, even line for my pen. I always work in a larger size than required so that when the image is reduced the lines look smoother and the image sharper.

Tracing paper Use to build up layers of doodles, which can be transferred to the light box. Join tracings with adhesive tape when planning a design.

Pencils Use a soft pencil – a 2B is ideal – for doodling, tracing, and working out rough designs.

Eraser I use a soft eraser to rub out any unwanted lines or adjust a design as I plan it.

Paints I work mainly in gouache, and all the images in this book have been created with permanent white plus just eight colours: Bengal rose; flame red; brilliant green; spectrum yellow; marigold yellow; ultramarine; cerulean blue and sky blue. Remember these are the magic ingredients of your picture, so keep the water clean.

Palette Use this for mixing colours.

Pot or jam jar For holding water.

Brushes It is hard to believe the illuminators of the past created such intricate work with the simple tools to hand. Thankfully we do not have to make our own brushes and can choose from a vast range. I achieve the fine strokes necessary for my detailed work with natural hair brushes, but less expensive alternatives are available.

Toothbrush An old toothbrush is ideal for flicking paint over areas of your design to create different effects.

Technical pens Ink pens have developed over the years, and you no longer have to spend ages unblocking the nib only to end up covered in ink as you try to refill it. Easy, clean cartridges which slot into place save a lot of time. My favourite brand of technical pen was found through trial and error, and I normally use either a 0.35 or 0.25 size according to the detail I am adding.

Protractor and set square Use the protractor to divide your design into accurate segments, and the set square for right angles.

Rule You will need this for measuring and for drawing straight lines.

Compasses You will need compasses to draw circles and arcs in your design, preferably with an attachment for holding pens and refillable pencils.

Masking tape Useful for fixing your design to a light box or working surface.

Self-adhesive memo notes Use to protect the edges of your design, or to frame areas which are to be speckled. The low-tack adhesive will not pull paint from the surface of your work.

Talcum powder Before working on an image I put a little talcum powder on a cloth and wipe over the paper to remove any grease on the surface.

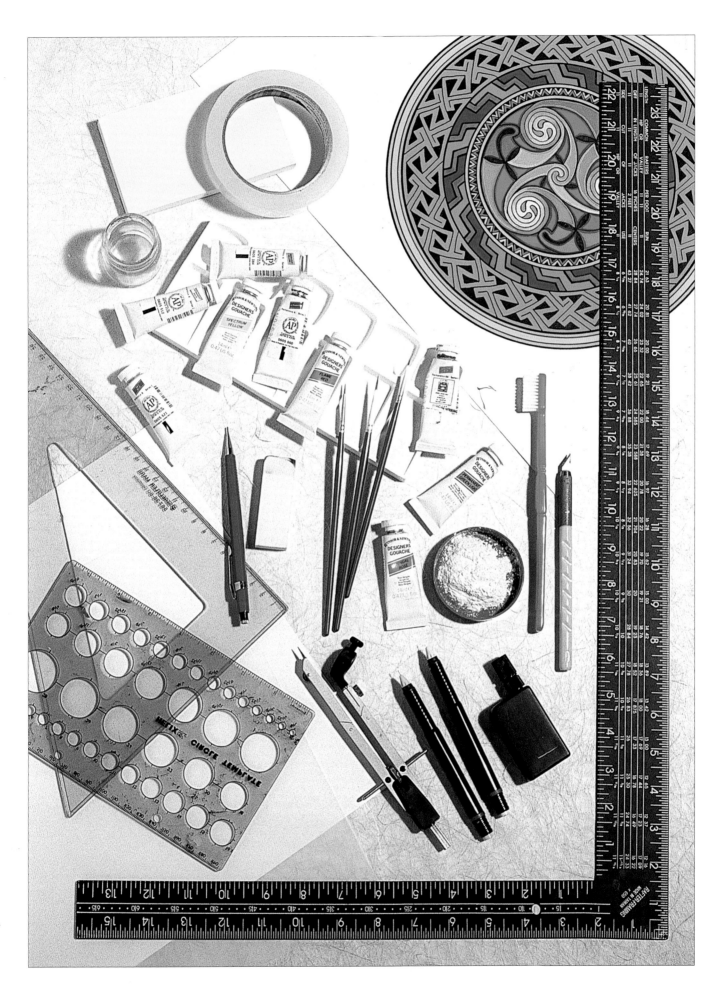

The light box

Though not absolutely essential, a light box will make such a difference to your work, you will wonder how you managed without one. You can buy one from an art shop or make your own, but before embarking on construction, make sure the glass will be at the angle you are most comfortable with when it is in working position.

In the photograph below, I have laid a larger sheet of glass over the light box to provide a bigger working surface. If you do this, make sure both the light box and glass are firmly secured before beginning.

I find it easier to fix my work to a loose sheet of plastic rather than to the glass of the light box. The point of compasses will 'bite' into plastic to give a good hold when you are drawing circles or segments, but it is bound to slip on glass no matter how thick the paper used. The plastic can be rotated to provide the most comfortable position as you complete different sections; you will not be able to achieve an even line if your body is at an awkward angle. Secure your drawing to the plastic sheet with adhesive tape, double-sided tape or pliable adhesive. If you have more than one plastic sheet, you can use it to work on roughed-out sections of your current picture. Extra sheets are also useful if you want to work on several projects at once.

TIP: Choose a light which will be kind to the eyes. Remember that bulbs can become very hot, while fluorescent tubes tend to stay cool.

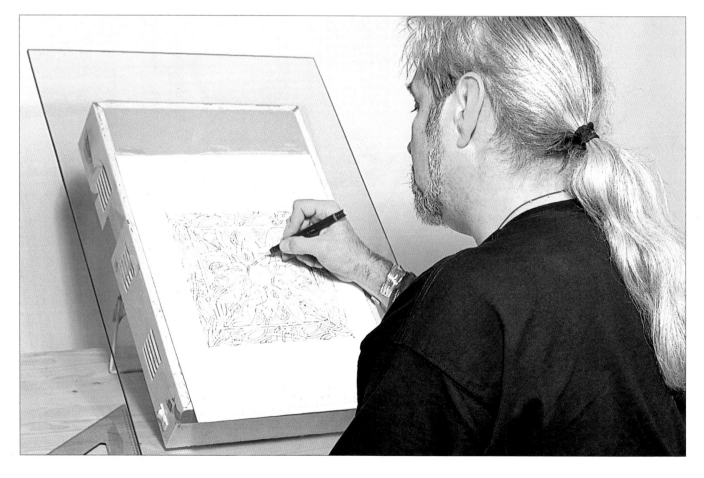

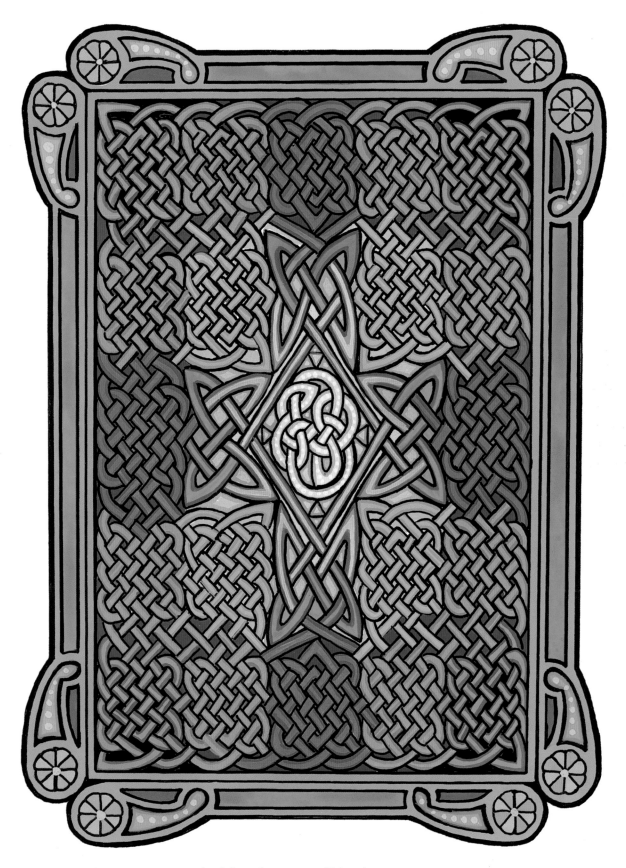

We speak of the rich tapestry of life. The Cosmic Pattern,
above, draws on the symbolism of the Celtic knot, capturing
the idea of the continuation of life, death and rebirth in an
endless knot with no beginning or end.

WORKING WITH COLOUR

Colour is one of the most universal of all types of symbolism. The intensity of colour and its purity correspond to the purity of symbolic meaning, and primary colours to primary emotions, while mixed colours express a more complex symbology.

Blue in Jungian psychology is associated with the clear sky and stands for thinking, and the Virgin Mary's robe is usually depicted in blue, probably because of her status as queen of heaven. Yellow and gold represent the sun, intuition and illumination; red represents blood and emotion; orange, fire and purification.

Green is a soothing, restful colour symbolising nature, growth and fertility, and predominates in Christian art because it is a bridge between yellow and blue. Purple – a mixture of the fire of red and the calm and thoughtfulness of blue – represents power and sublimation and is the colour of the Cardinal's robe.

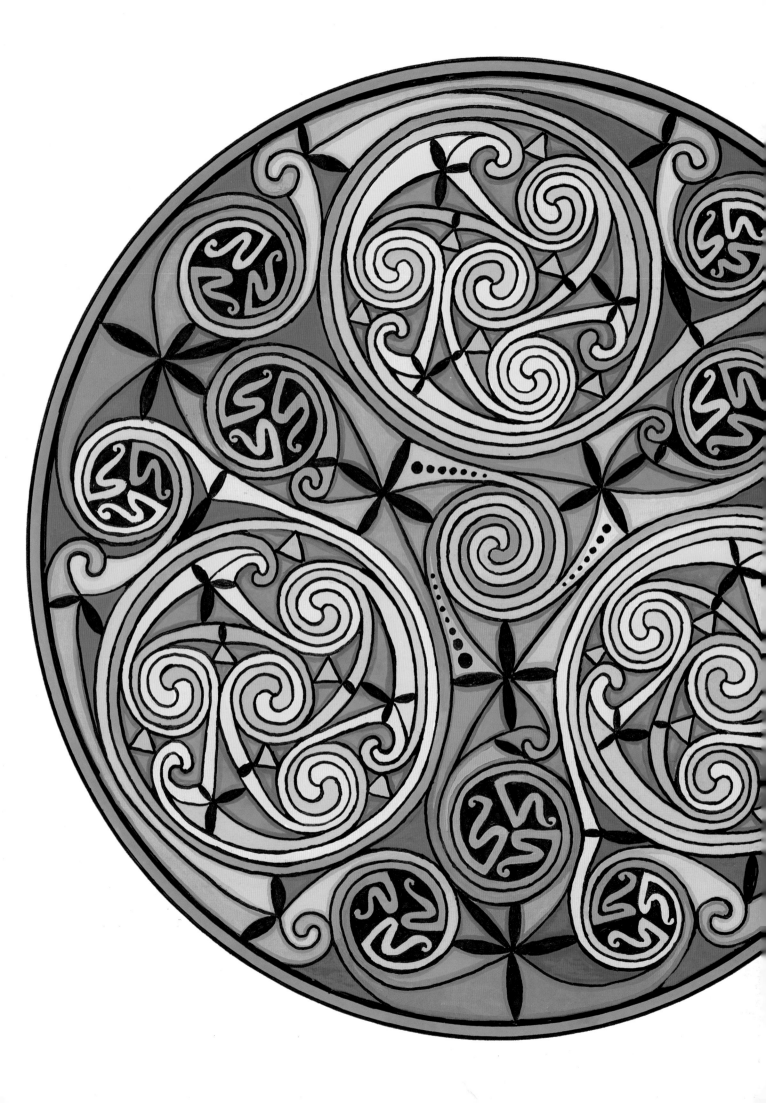

Effective use of colour

We live in an extremely colourful world, and are daily bombarded with glossy and bright images in newspapers, magazines and the junk mail landing on our doormats. Have you noticed that some of the slickest and most polished promotional material uses colour sparingly, and for that reason it stands out from the rest? Companies spend vast sums choosing the right colour for a product label or site, as they know that one colour can create the right ambience while another will kill it.

Many years ago when I exhibited my work on the UK craft circuit, I sold a lot of hand-coloured prints, which I produced conveyor-belt fashion throughout the winter months. I was amazed how my mood of the day was reflected in the finished pictures; the same print finished on another day had a totally different colour range and feel.

When we tell someone: 'That colour doesn't suit you,' on what is that judgment based? Perhaps we are looking beyond skin tones and, unconsciously, 'seeing' something else. Many people believe they can see an auroric field which surrounds each of us, and that when we say someone is 'green with envy' or 'red with rage' we are not far wrong.

I receive a constant stream of mail from people who have bought my books, asking for ideas on the colours they should use for projects rather than trusting their own judgment. If you consider the different energies we are working with and how each contributes to the make-up of a colour, its location, its properties, and how it touches our senses, it is easier to understand the power that lies in our palette.

One of the most inspiring moments of my career was after a talk I gave to a group of twenty adults at St James' Church, Piccadilly, London. Members of the group were spread around on the floor, happily colouring in black-and-white prints I had brought. I moved around chatting and the discussion turned to the last time they had coloured pictures, and how they had forgotten the pleasure to be gained.

Some of the pictures were very dark, and the people who had coloured them told me that they were going through rough times. I suggested that they should start again, this time visualising a happy conclusion to their troubles and using gentler and more peaceful colours, so the pictures could be used as a focal point next time they were distressed.

Before working on your picture, make some photocopies of it and try to let the colours choose themselves. If the result is a mess, fine – it is only a photocopy. With perseverance and by letting instinct and inspiration rather than will guide your brush, you will begin to tap into another level of satisfaction with your endeavours.

TIP: I am often asked how I control the stroke of my brush and pen as I work, and one of my most important tips is to control breathing. I find that controlling exhalation as I work creates a stillness of self and smoother hand movements.

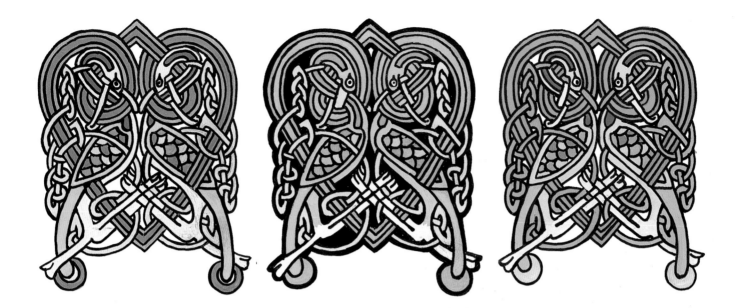

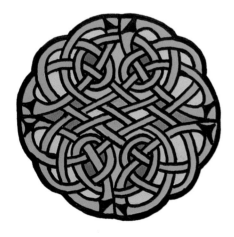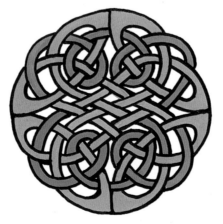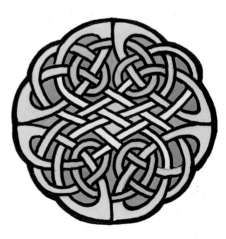

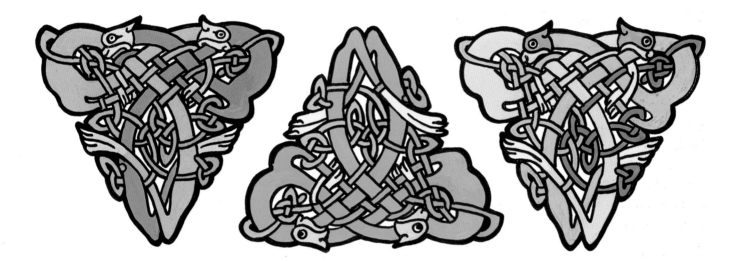

*The examples above show the effect of
different colours on the same design*

KNOTWORK

The very sound of the word knot conjures up an image of difficulty and problems, though there is also the more positive image of tying the knot, and uniting two souls in marriage.

At first glance, knotwork patterns can be overwhelming in their intricacy, but it needn't be so. I never look under the bonnet of my car because I am terrified that I may cause more problems than my Neolithic mechanical brain can deal with. If you are the same, remember it is just fear of the unknown, and that a few lessons in basic car mechanics will work wonders. You may never aspire to the mystical reaches of the broken 'big end' but when things are explained simply, you will at least be able to fill the screen washer. So it is with Celtic artwork, and as you work through these pages the mechanics will become clearer.

Remember the feeling of relief when you manage to undo a spectacularly difficult knot; that sense of achievement over adversity – and perhaps even the discovery of a few brief moments of stillness as a reward.

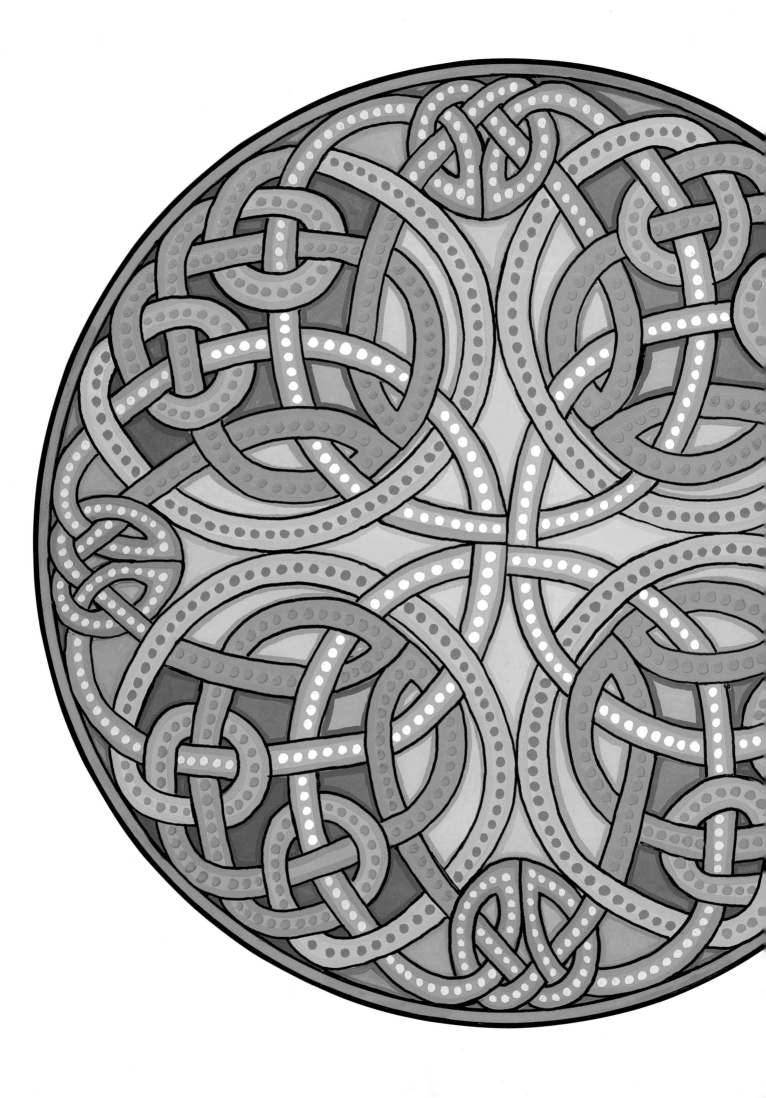

The Sacred Thread

Simple plaitwork designs can be traced to ancient Greece and to artefacts from prehistoric Mesopotamia. Thousands of years before Celtic artists adapted these patterns they were powerful symbols, used daily as spiritual tools to help with hunting for food and in the veneration of the Creator. Shetland fishermen believed they could control the winds by the magical use of knots. A knotted cord forms a ring which signifies both an enclosure and a protection. The silver cord in Vedic teaching is the connection between the physical body and the astral body, broken at the point of death so the spirit can journey into the next world. A continuous thread twisted into a figure of eight emphasises the relationship of the knot with infinity, and is its most popular significance in Celtic art today.

Although knotwork is widely regarded as the main Celtic pattern form, it came into use after spirals, zoomorphic, key and step patterns. It was useful for filling in broad and difficult areas on stone and vellum. Craftsmen who experimented with the monotonous plaitwork found that by breaking the bands, they could introduce new patterns of complex knots and widen the scope for secondary designs.

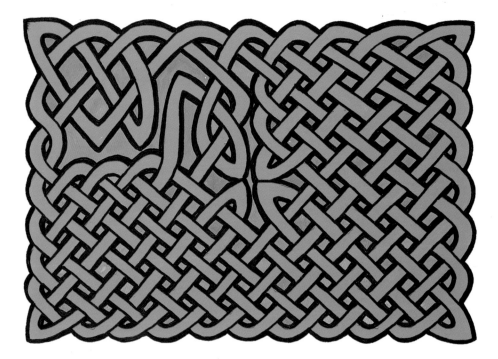

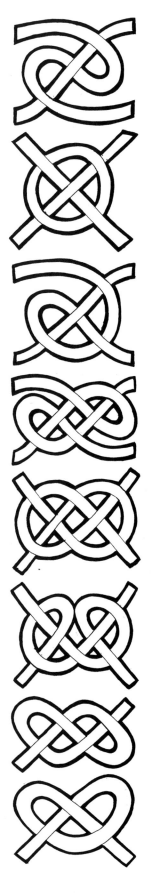

Above: the panel shows how a uniform knotwork design can be broken into, creating patterns within patterns.

Right: In 1904 J Romilly Allen, an early specialist in the field of Celtic art, identified eight basic knots which he believed to be the basis of most Celtic knotwork.

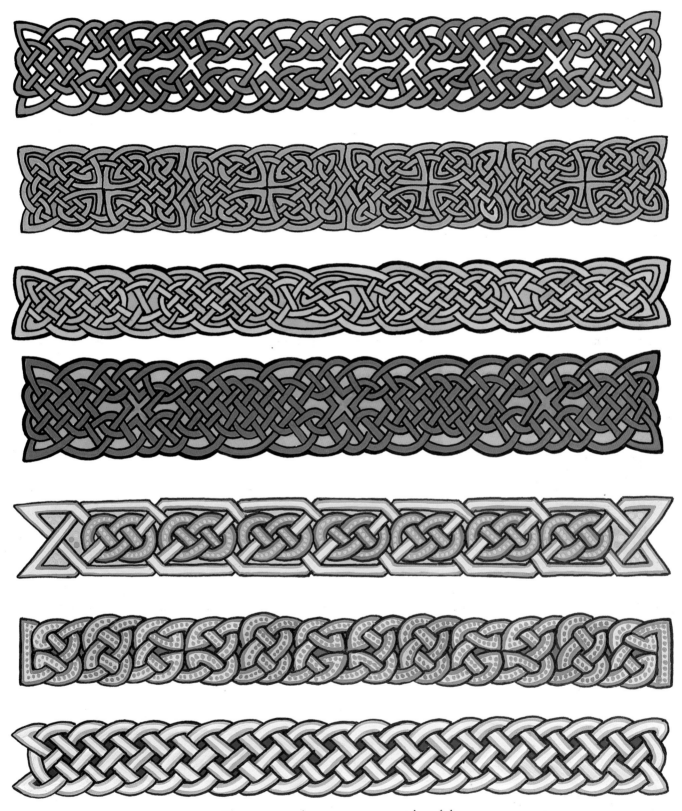

*The patterns above give you some idea of the
many variations which can be achieved with
single and multiple threads.*

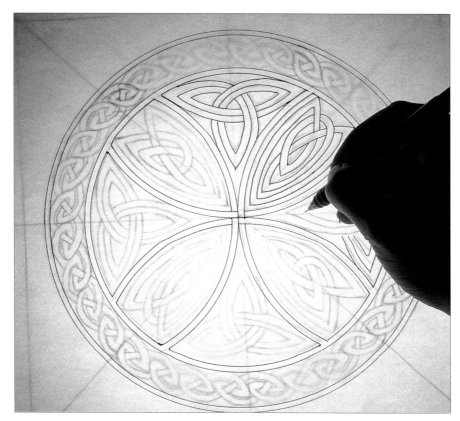

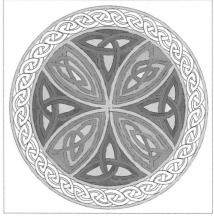

14. Begin to fill in the design, using a No. 2 brush. Here I have used Bengal rose with a dash of white, then Bengal rose blended with yellow.

13. Transfer the rough design to the light box. With a technical pen, mark the outlines carefully, neatening any lines and refining areas.

15. Build up the design using colours of your choice.

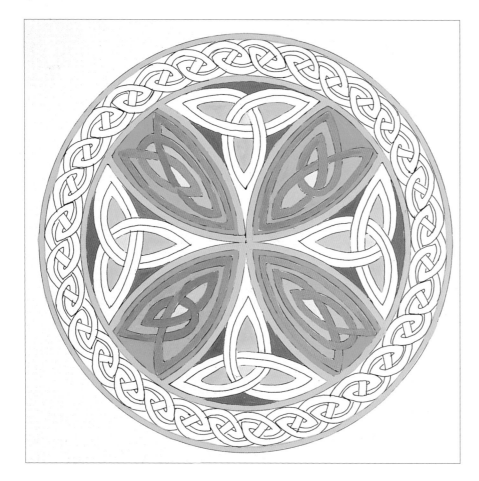

16. Complete the inner circle and begin work on the outer border of your design.

24

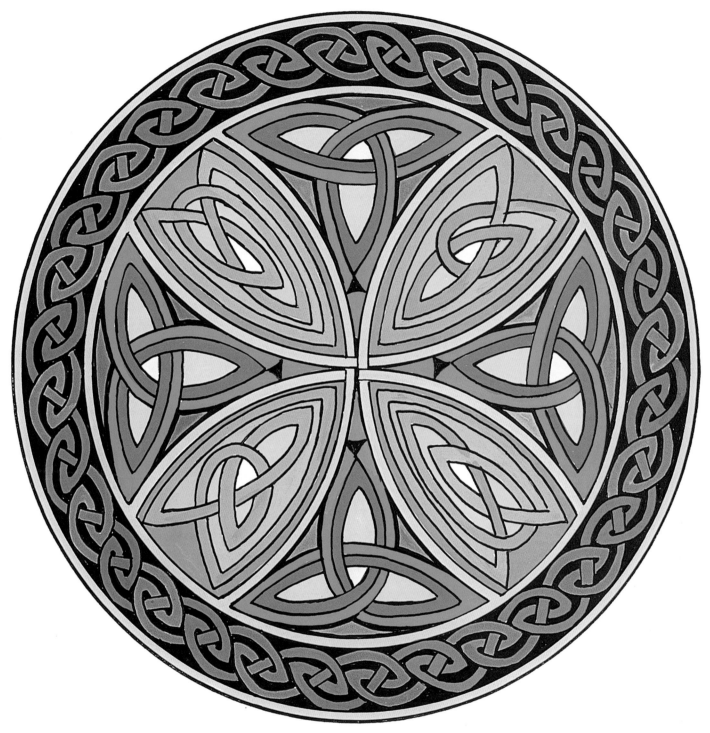

The completed knotwork design

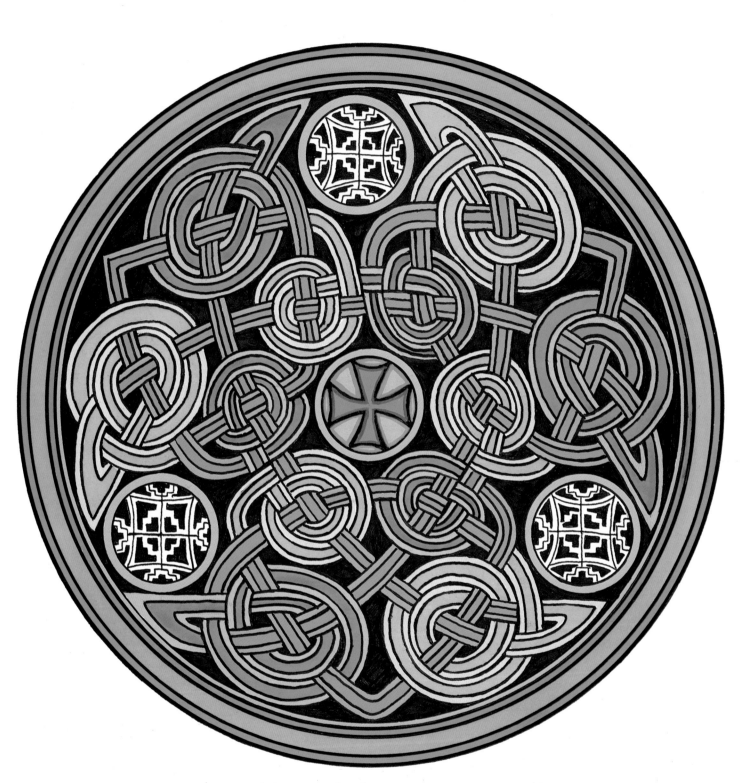

Knotwork designs can be adapted to any shape, and careful choice of colours can complement the intricacies of the pattern. The example above is from the Book of Durrow.

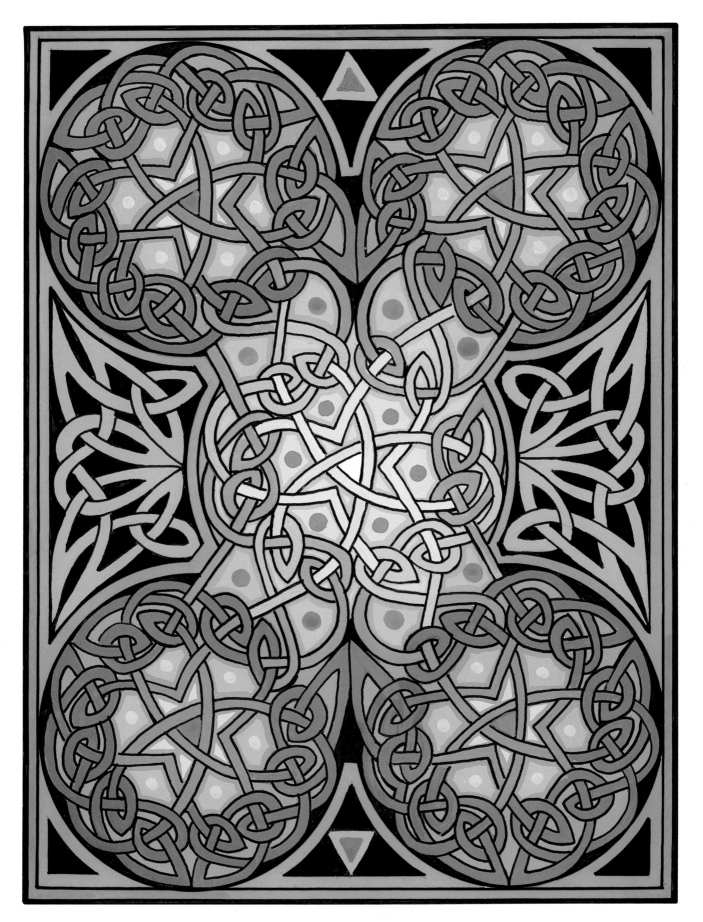

The Empowering of the Spirit, above, was created by duplicating and adapting the simple knotwork at the centre of the picture.

Knotwork borders

The idea of creating a knotwork border that will join up neatly can be daunting, but with some tracing paper or a light box, photocopier or scanner anything is possible. Using either tracing paper or a light box, create a rough of your proposed border – which can be square, oblong or round – then quarter it up. Decide which knotwork panel you intend to use, to determine the thickness of the band of the border. Instead of trying to design the whole border at once, the steps opposite begin by working on one section at a time, inserting one section of border before moving on to the next.

TIP: Simple knotwork patterns are very useful to end or link one or more spiral bands.

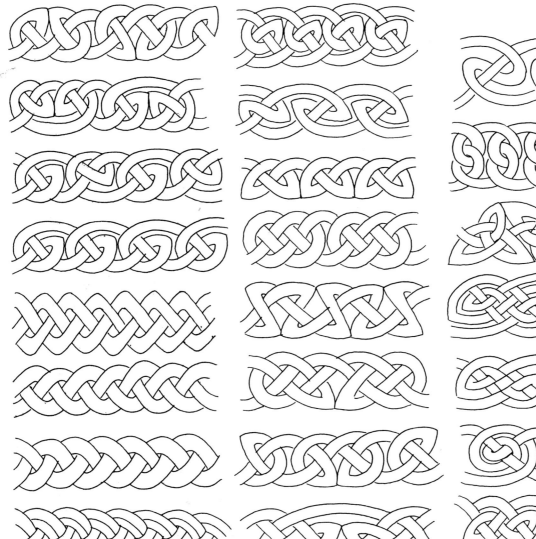

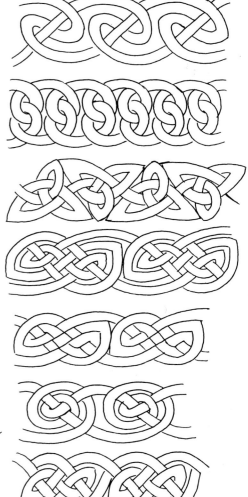

You might like to choose from this selection of knotwork panels, copying, enlarging or reducing to fit.

Square border

1. Draw a square and divide it into four equal sections.

2. Choose the border you wish to use. You may find it easier to choose from the selection left.

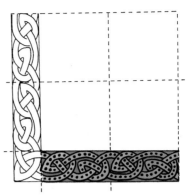

3. Mark out the border area and quarter the square left inside. This gives the width of each section and leaves a box in the corner.

Circular border

1. Draw a circle using compasses and divide it into four segments.

2. Choose the border you wish to use, noting that each section will have to be adapted to fit the curve of the circle.

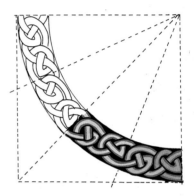

3. Mark out the border around the edge. Divide the segment to produce the individual panels.

The completed segment, with the sections of border shown in different colours for clarity.

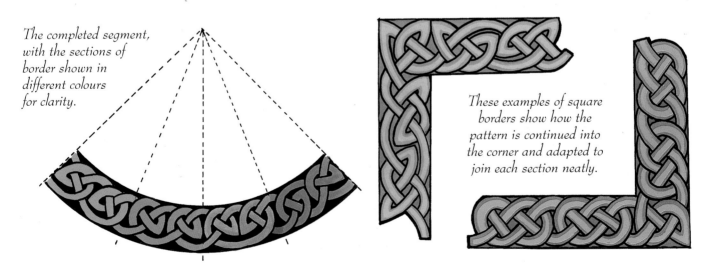

These examples of square borders show how the pattern is continued into the corner and adapted to join each section neatly.

Knotwork designs may seem complicated, but
will become easier with practice — why not try
a square or rectangular variation?

*This selection of knotwork borders
may help you to gain the confidence to
begin designing your own.*

SPIRALS

The spiral was the earliest decorative motif used in Christian Celtic art, but with the corruption of Celtic illumination it was also the first to disappear around the 10th century AD. Its symbolic centre is that of the Most High God round which all things revolve, the spirals stretching from the centre emphasising this movement.

With the circle, the spiral is probably one of the oldest patterns used by man. It is seen time and again in nature, and in art the whorls have been used to represent the evolution of the universe and the growth of nature. It features in primitive dance rituals for healing and initiation ceremonies, symbolising escape from the material world and entry into the Otherworld through the 'hole' represented by the mystic still centre.

Although spiral ornamentation appears complicated, I gain more pleasure from the creation of spiral designs than from knotwork and key patterns, and great satisfaction from winding and unwinding the coils from one to the next.

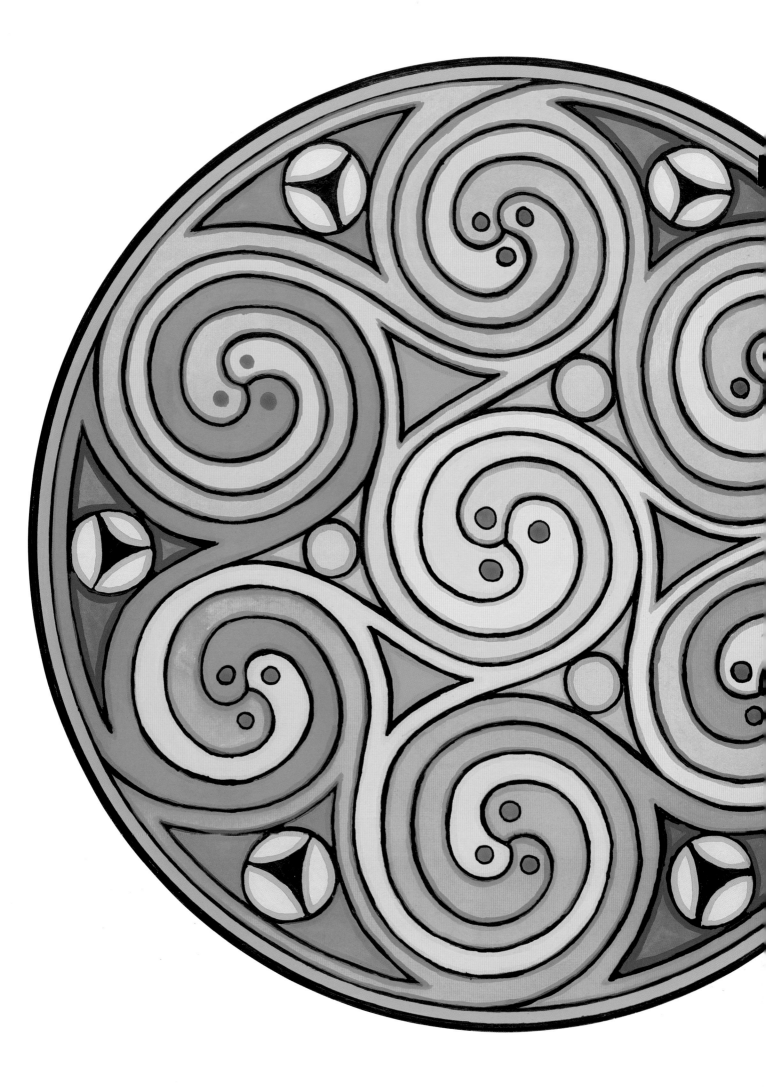

A sense of balance

Many spiral patterns achieve a sense of balance by contrasting clockwise (positive) and anti-clockwise (negative) spirals. In Neolithic times, the spiral seems to have been an essential barrier to the inner sanctuary of a stone burial chamber, like the stone at the entrance to the tomb at Newgrange in Ireland (below). The passage beyond the entrance stone symbolised the soul's journey from death to rebirth at the still centre. The inner chamber of the tomb was used for both meditation and initiation, and the early Celtic saints continued this tradition by using rock cavities and beehive stone huts for meditation and prayer.

The patterns on the facing page have been broken down to show the method of construction.

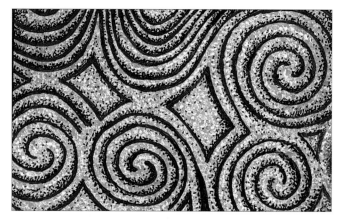

Spiral patterns decorate the chambered cairn at Newgrange, Ireland, which dates from 3200 BC.

Bronze scabbard blade engraved with spiral designs; Ireland 300-400 BC.

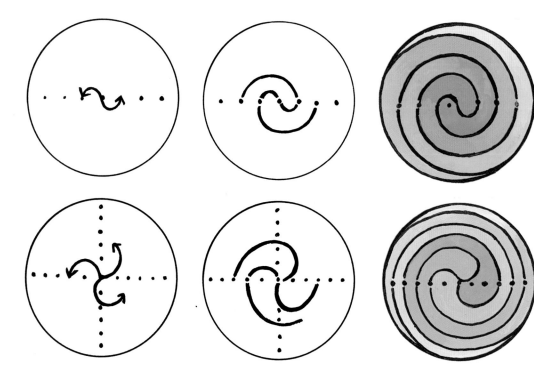

The single-coil spiral is found in many parts of the world, and had been unchanged for centuries until Celtic scribes adapted it by adding two, three or four coils.

34

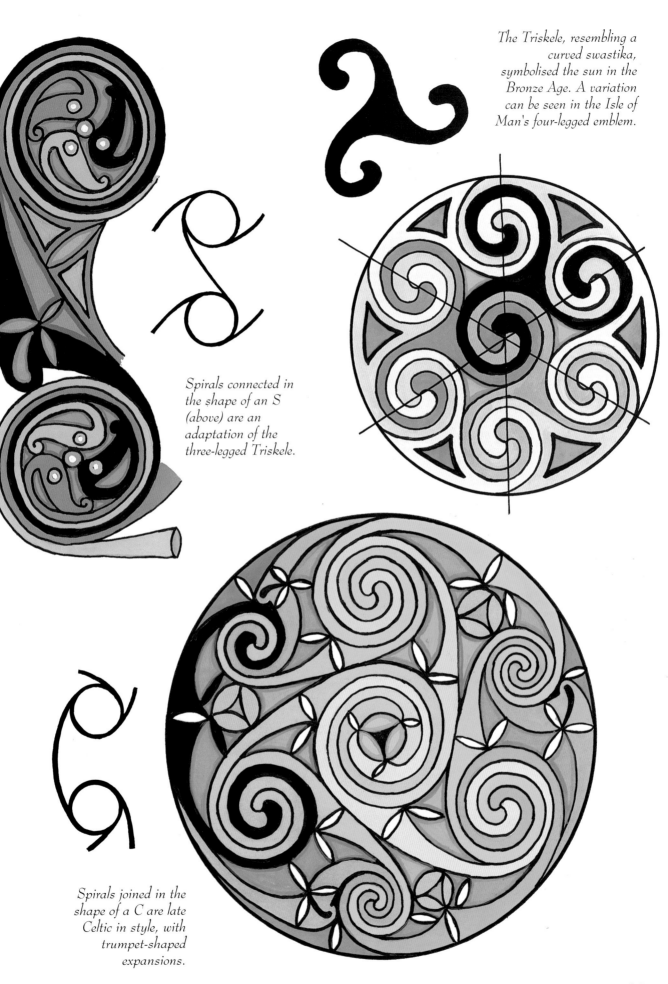

The Triskele, resembling a curved swastika, symbolised the sun in the Bronze Age. A variation can be seen in the Isle of Man's four-legged emblem.

Spirals connected in the shape of an S (above) are an adaptation of the three-legged Triskele.

Spirals joined in the shape of a C are late Celtic in style, with trumpet-shaped expansions.

35

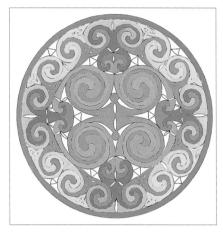

10. Paint in the border using Bengal rose. Adding a touch of white will help to even up this colour, which can be a little patchy over large areas.

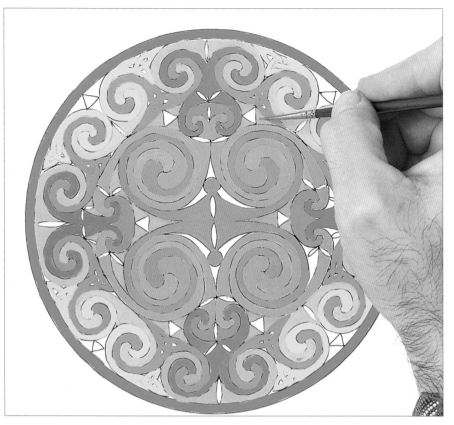

11. Change to a No. 000 brush and begin filling in the centre of the design using Bengal rose with a touch of yellow spectrum.

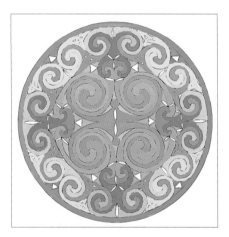

12. With undiluted Bengal rose, pick out details round the edge of the design. Change to black and fill in the final areas.

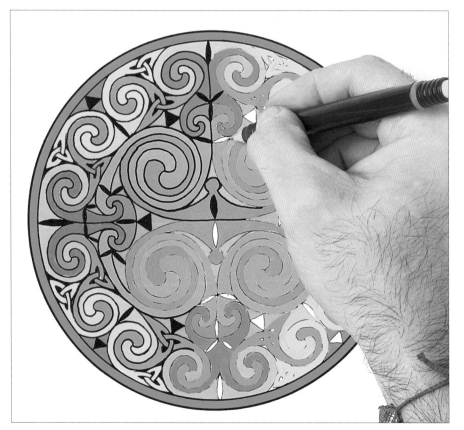

13. Outline the design with a technical pen.

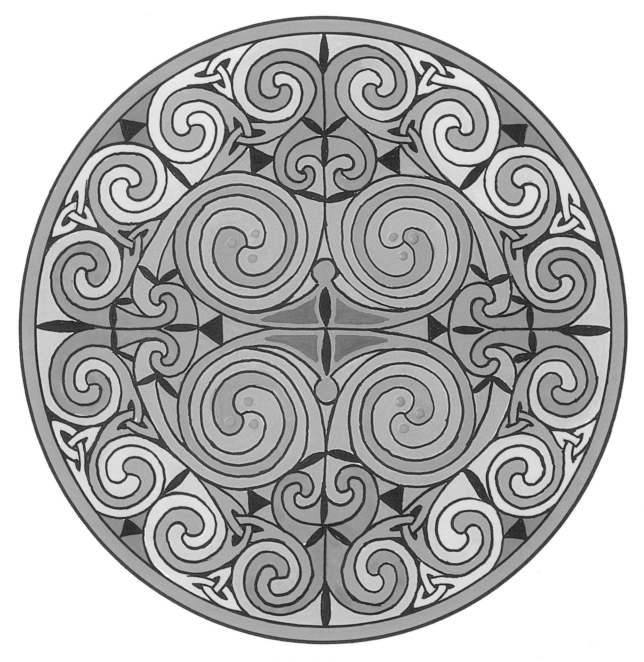

The finished design

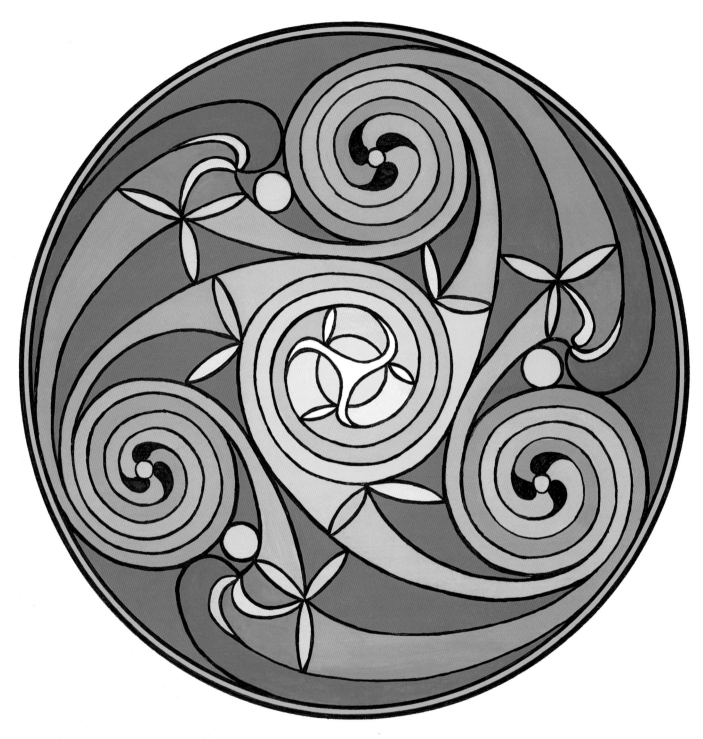

A spiral modified from a design in the
Book of Durrow

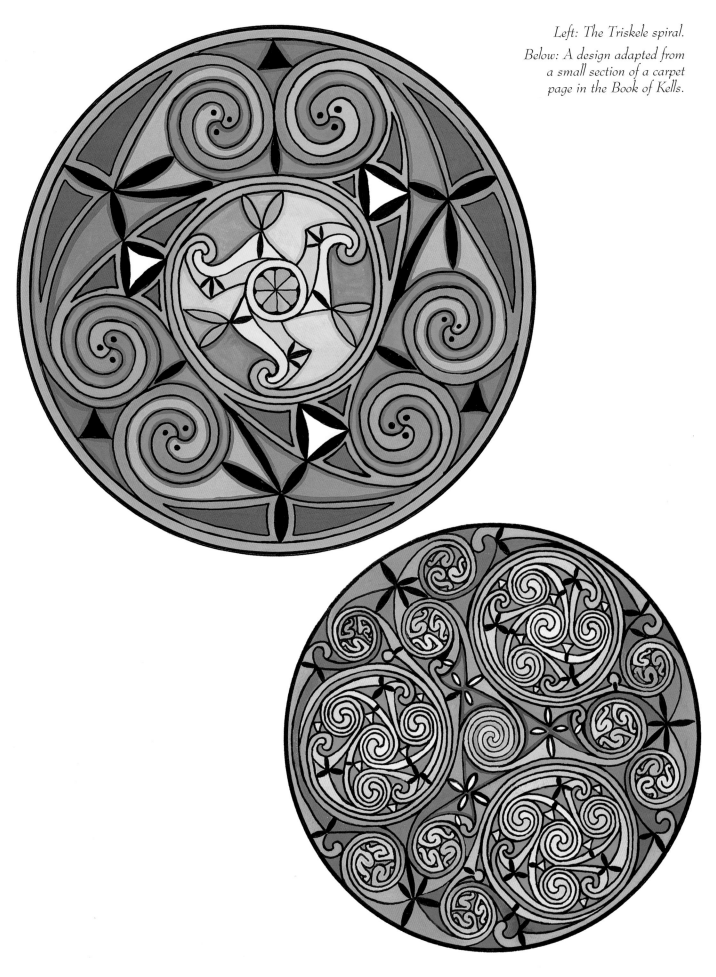

Left: The Triskele spiral.
Below: A design adapted from a small section of a carpet page in the Book of Kells.

41

Spiral borders

Once you have chosen a design, the easiest way to begin is to consider how the corners will work. I have given examples, some of which could be adapted to work with similar patterns.

If you use tracing paper to overlay a corner, you should begin to see ways to align the border so that the movement of the pattern flows naturally without looking clumsy. Make sure you are completely happy with your design for the corner before continuing, so that you will not have second thoughts when you begin to paint the finished work and end up with a disappointing result.

When you have overcome this hurdle, you can begin to section up and trace out the rest of the border, segment by segment. If you need to stretch or compress the design to fit, it is best to do it from the spiral tails.

TIP: Any large spaces left between the spirals can be filled with triangles, circles and half-moon shapes.

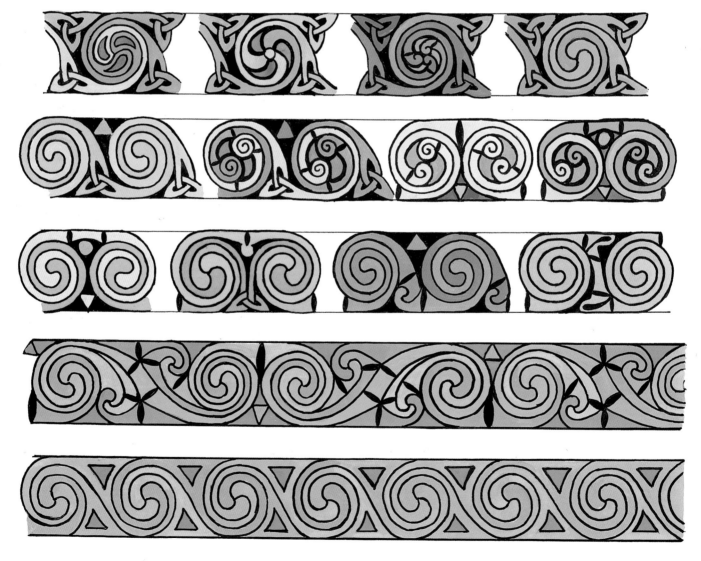

42

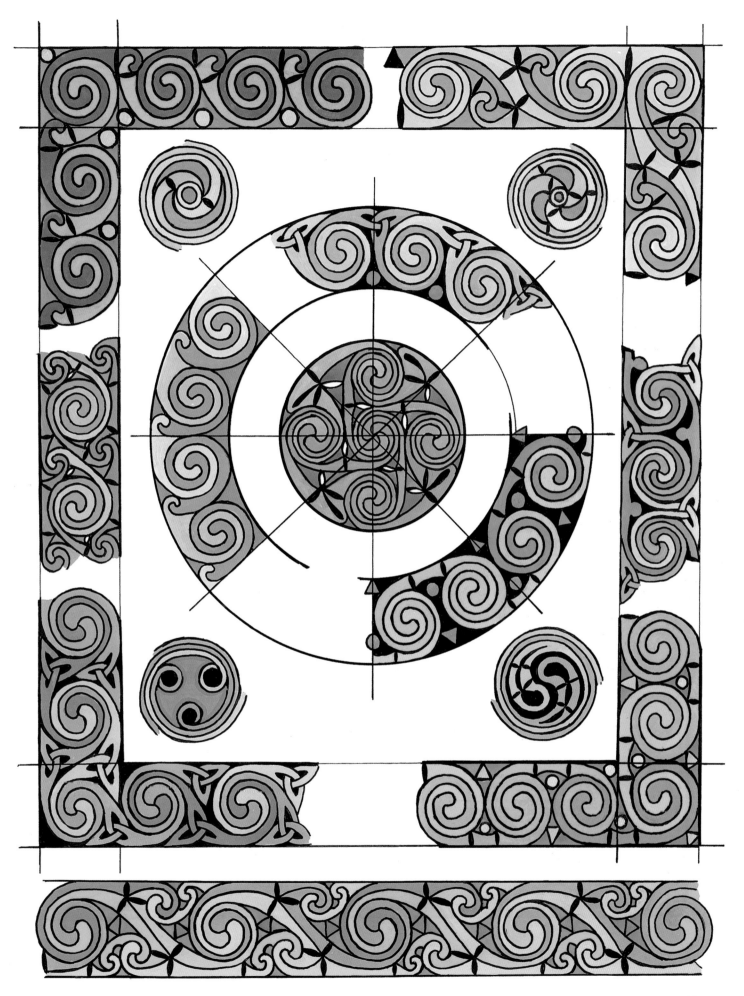

43

KEY PATTERNS

The key pattern is an elaboration of the Greek key or fret design. The earliest examples were discovered in Russia, carved on mammoth tusks dating from between 20,000 and 10,000 BC.

At first, key patterns were used mainly for borders. Later, Christian Celts developed them into complex, maze-like panels which featured strongly on stonework and manuscript decoration. I am constantly amazed by the skill with which these complex patterns were created.

Key patterns played a significant part in Celtic design, especially in the Christian era, though this is often overlooked. The golden age for the key pattern was between the 6th–8th centuries when the scribes and stone carvers were at their most inventive. The style became progressively less popular, however, and it is unknown in late Celtic art.

It takes time to assimilate the complex structure of key patterns, but it is worth persevering as they are ultimately extremely rewarding. I hope these pages will encourage you to experiment further with key patterns, as they can look very dramatic and pleasing when completed.

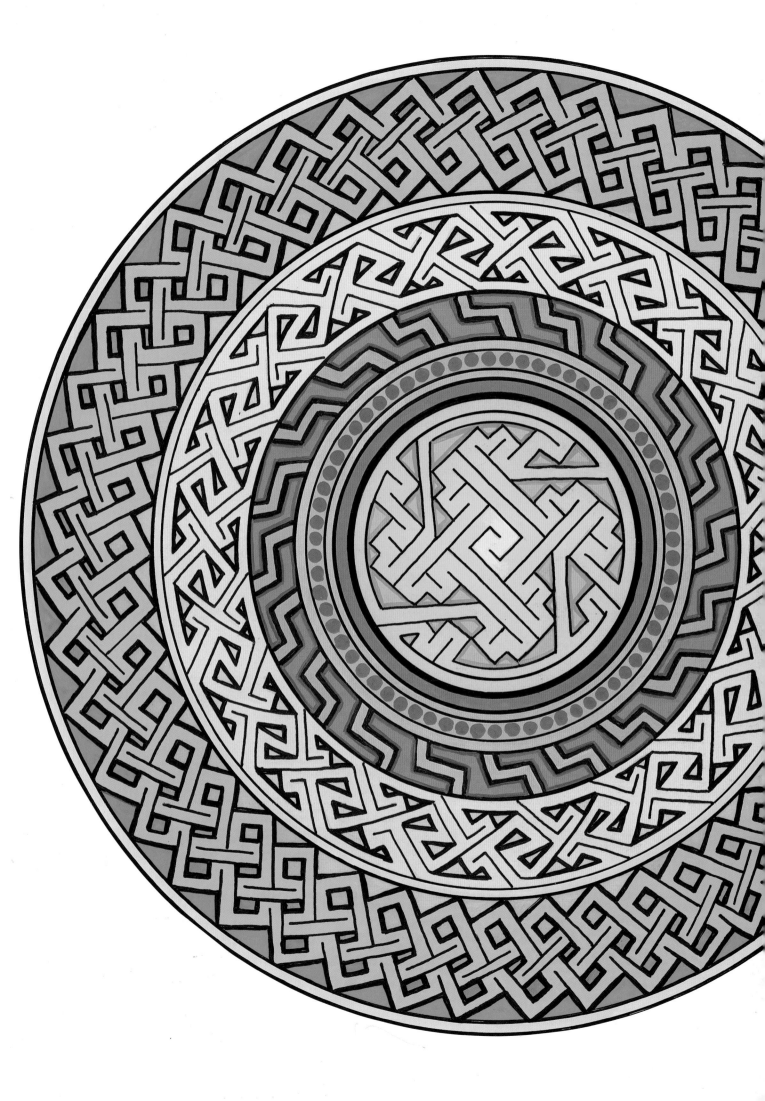

The Sacred Dance

Key patterns and spirals are thought to have had a solar connotation and are also associated with fire and the spirit. When connected, the geometric key pattern becomes the *Sacred Dance,* a processional path leading through a complex labyrinth to the sacred Omphalos at the very centre. This is also linked to the ancient turf mazes which were used for ceremonial purposes during Druid festivals.

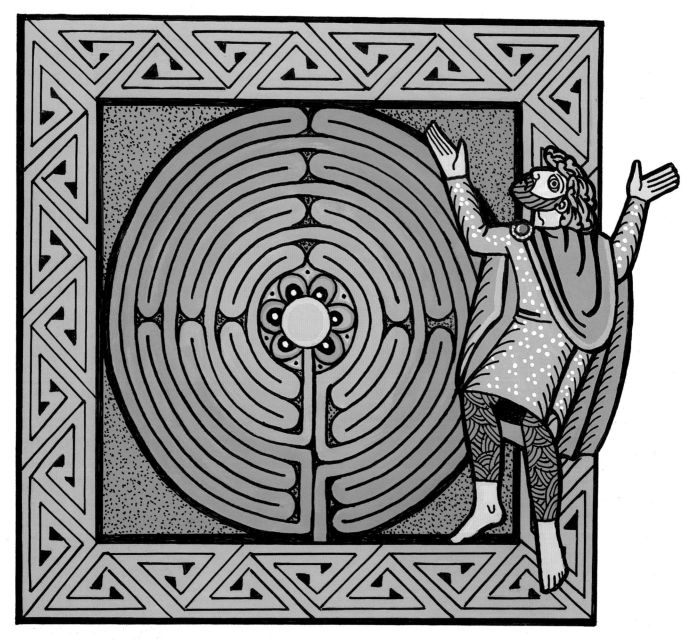

The maze at the centre of this design derives from the floor of Chartres Cathedral, France. Built on the site of a Druidic grove, the Chartres labyrinth is a journey of devotion equivalent to a pilgrimage to Jerusalem.

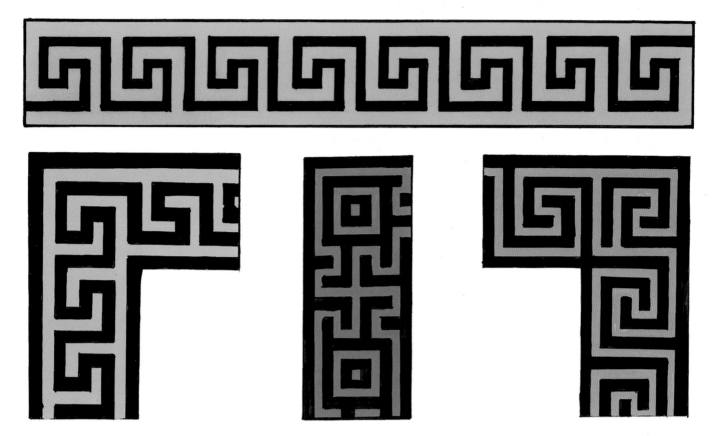

Above: the examples show how, as with knotwork and spirals, highly-skilled Celtic scribes adapted Greek key patterns to produce the complex designs which continue to amaze us today.

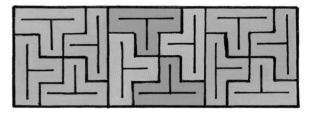

This key pattern is taken from the Nevern Cross, Pembrokeshire, Wales.

Left: the illustration is from the base of the stone Cross of Hywel ap Rhys, Llantwit Major, Wales.

49

Designing key patterns

I have always found key patterns the most difficult to work with, and it does not surprise me that the style became progressively less popular before falling into disuse. The Celtic scribes worked out much of the initial design on wax tablets, but fortunately we have modern aids like tracing paper to make things a little easier.

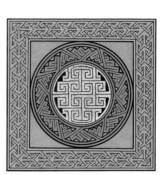

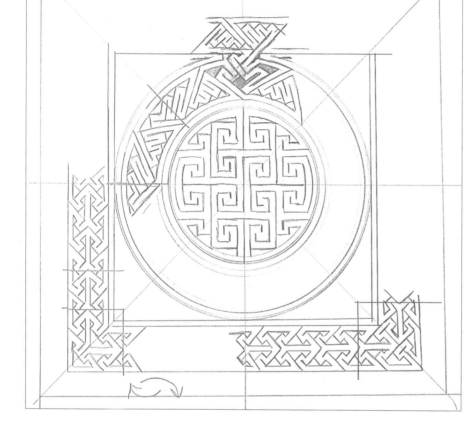

1. The rough design, partly completed to show the different stages.

2. Draw a grid on a sheet of tracing paper, place it over the rough design and draw in guide circles.

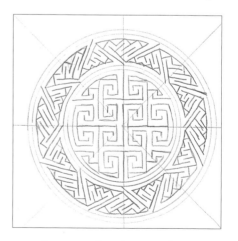

3. The completed central pattern.

5. Complete the top corners and insert guidelines for the border grid, noting that the design will repeat in opposite corners.

4. On a separate piece of paper, draw a rough sketch of the lower corners of the outer border. The initial design has been simplified.

6. Repeat a section of the corner pattern in each border grid segment to build up the design.

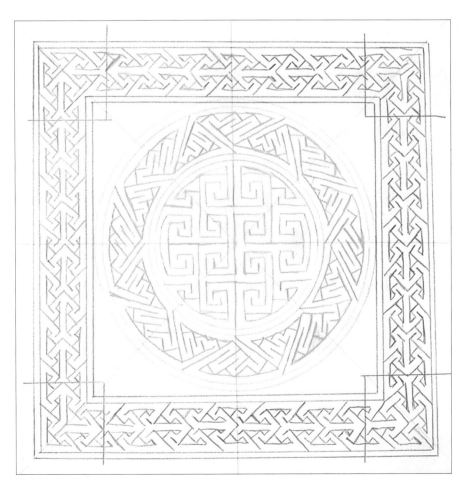

7. The completed rough design, with border.

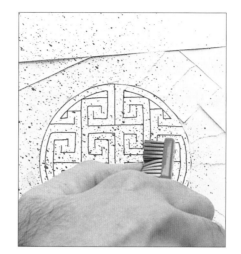

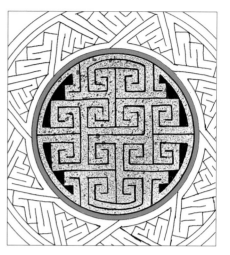

8. Mask centre circle with layered strips of self-adhesive memo sheet.

9. Lay paper round the rest of the design to protect the background. With a toothbrush, flick on spatters of cerulean blue.

10. Build up the outlines of the central design with a technical pen.

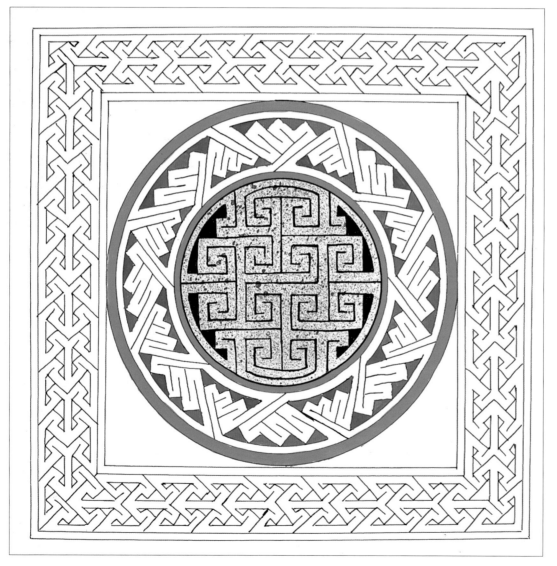

11. Build up the central pattern using sky blue and red.

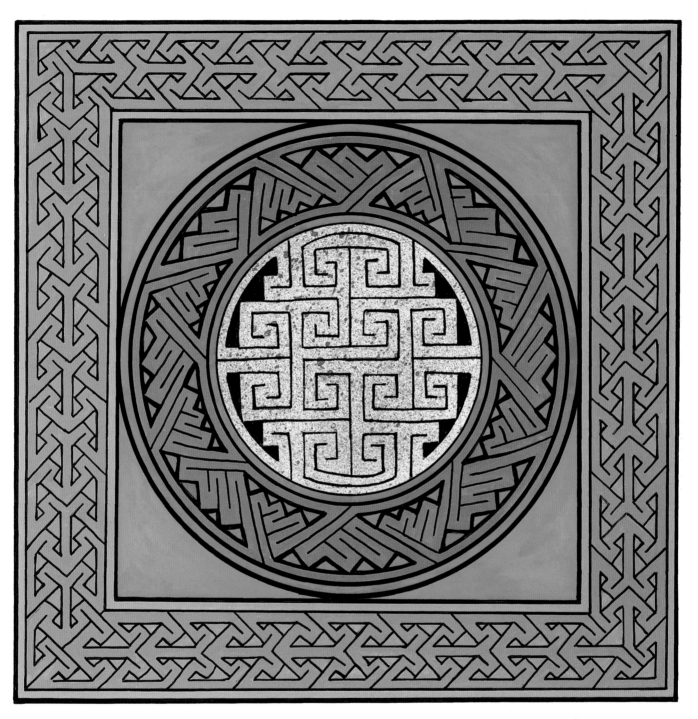

The multicoloured stippled effect at the centre of the finished design can also be seen in the illustrations on page 34, and the illustration derived from the stone base of the Cross of Hywel ap Rhys on page 49.

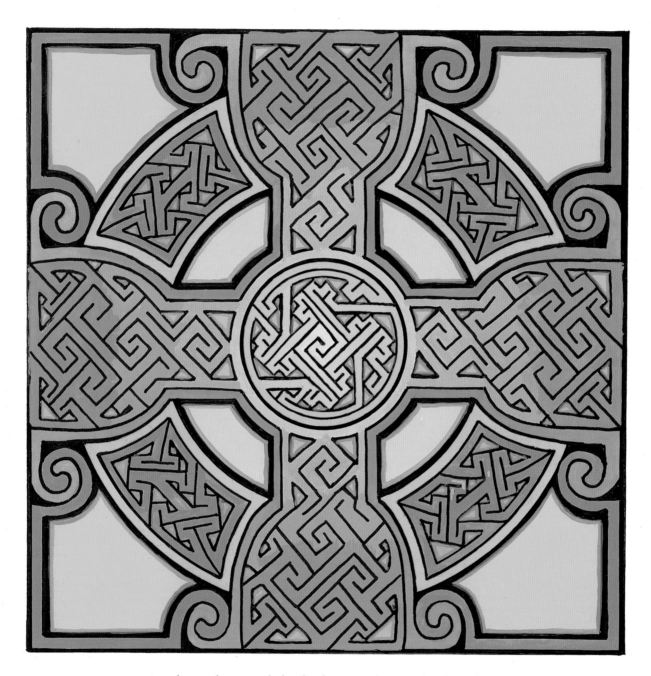

Above: The original idea for this cross design came from the tombstone of St Berchtir at Tullease, County Cork, Ireland.

Right: This illustration shows how key patterns can be visually powerful, though they are not as fluid as some of the other Celtic styles and are more suitable for borders and panels.

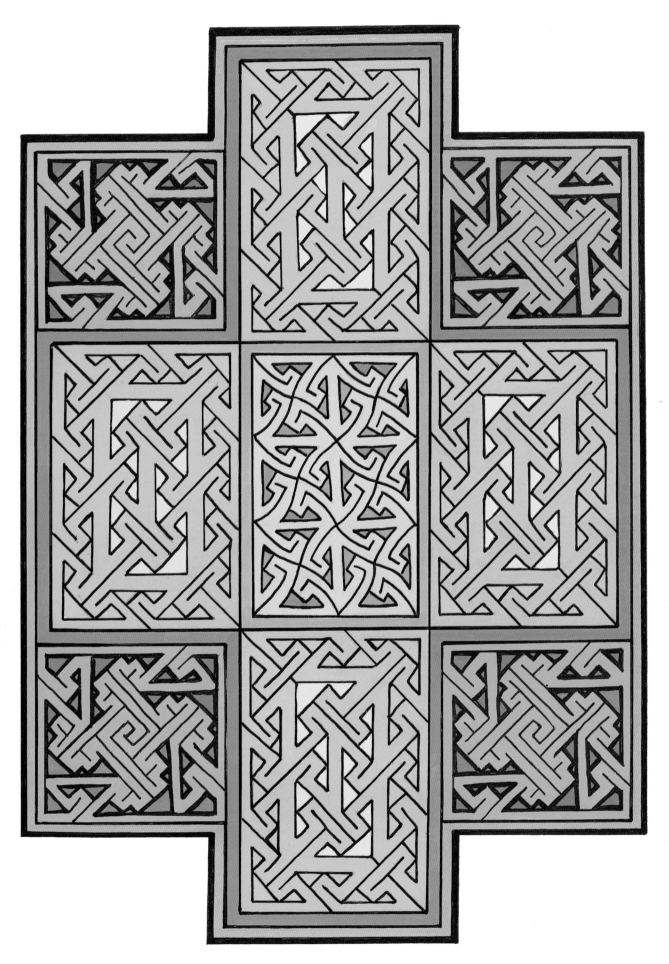

55

Key pattern borders

As with the other patterns, work out the corners first. Remember that the direction of the pattern on either side of the corner will probably be different, so your tracing will have to be flipped.

If you look at the borders opposite you will note that they move in opposite directions, so your template will need to be flipped over on alternate sides. This means there will be two different corner patterns, as you can see from the example below.

You may find that you are left with a small gap when you have worked your way round the border with the template. Do not panic; although Celtic patterns may look precise, it is in fact possible to cheat a little. Try extending or reducing the legs of the bands a little until they do fit. It is more than likely that the adjustment will be unnoticeable.

Although key pattern borders require patience and concentration, they can look extremely dramatic when completed and it is well worth persevering with the technicalities. Experiment by using shading moving from light to dark; with multicoloured effects; colouring detail in black to make the pattern appear to stand out in relief, or by flicking paint on the finished border to give a carved stone effect as shown on page 47.

TIP: To keep your ideas fresh and flowing, do not be afraid to experiment with different ways of creating your pictures. Play with new materials and try to create your own, recognisable style of work.

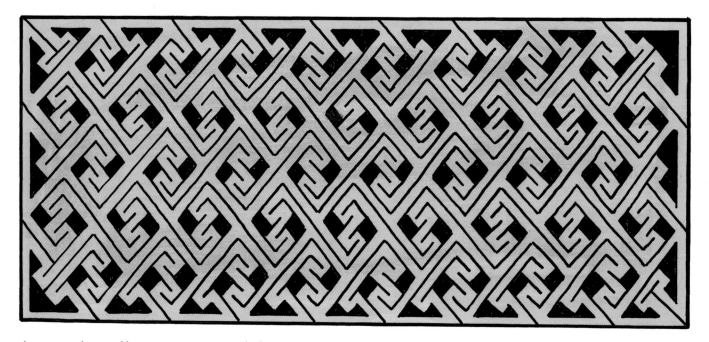

The precise forms of key patterns require a little perseverance, but can produce an extremely dramatic effect.

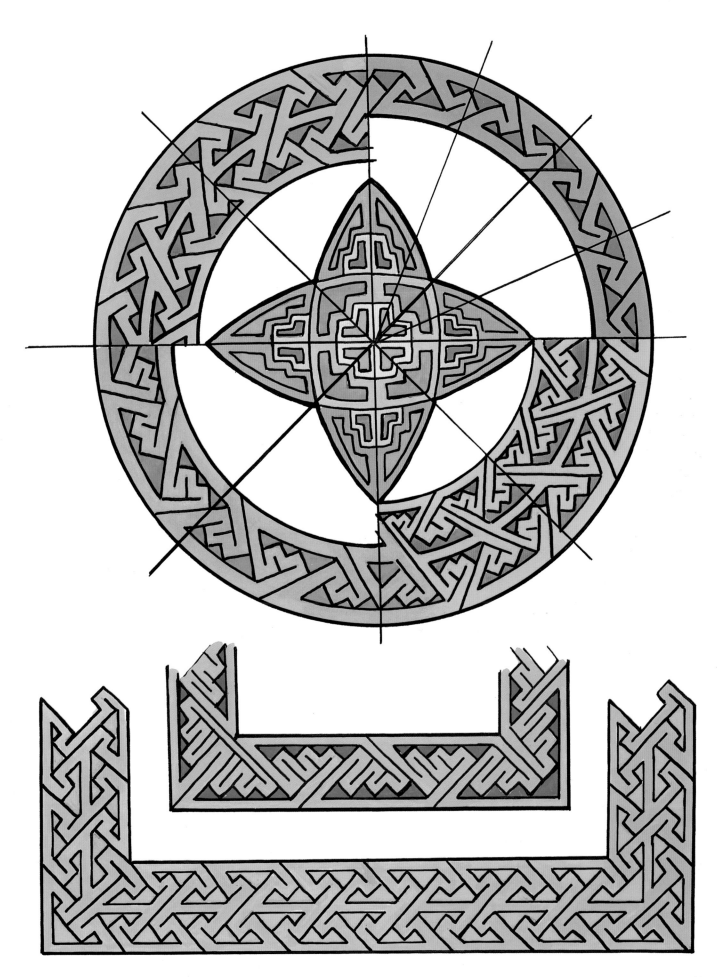

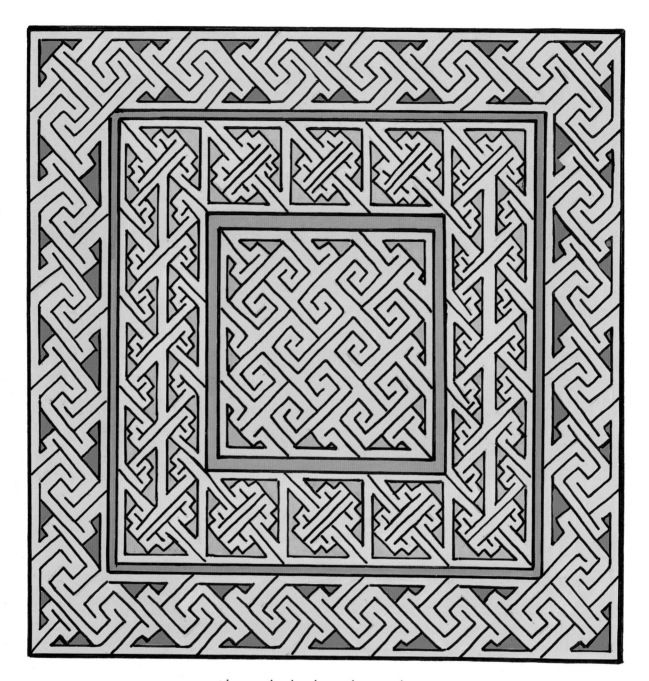

Above and right: these selections show how key pattern borders can be adapted to fit different shapes of design.

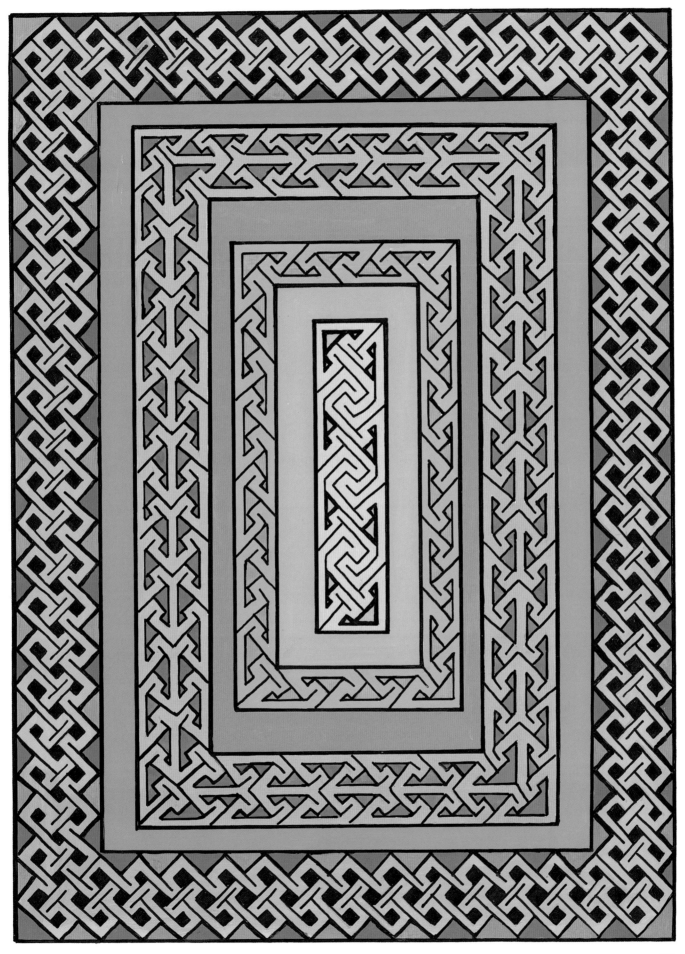

59

Step patterns

These patterns resemble a flight of stairs: the lines are often arranged symmetrically round a centre, and shaded alternately light and dark. Step patterns appear very seldom in Christian Celtic art except on enamel bosses of metalwork. The resemblance of the designs to the carpet pages in the Lindisfarne Gospel leaves us in little doubt that the illuminators were greatly influenced by metalworkers and enamellers.

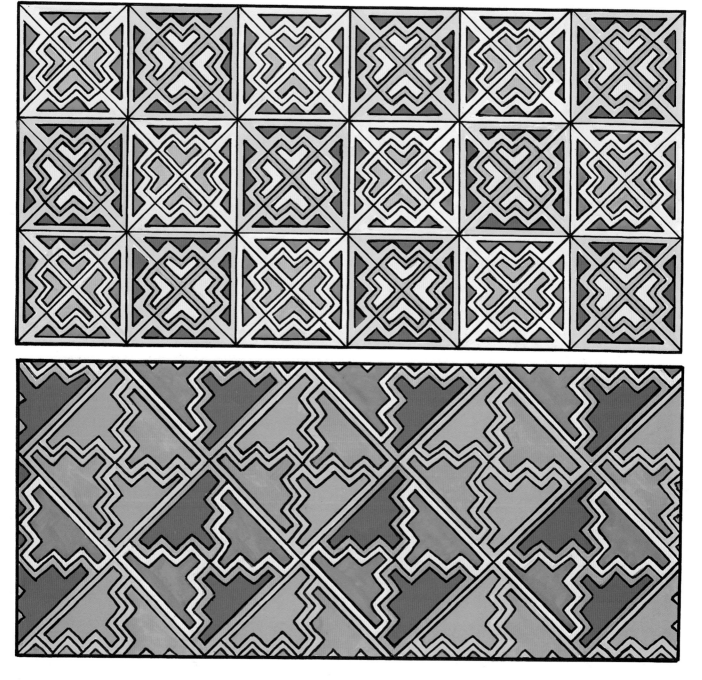

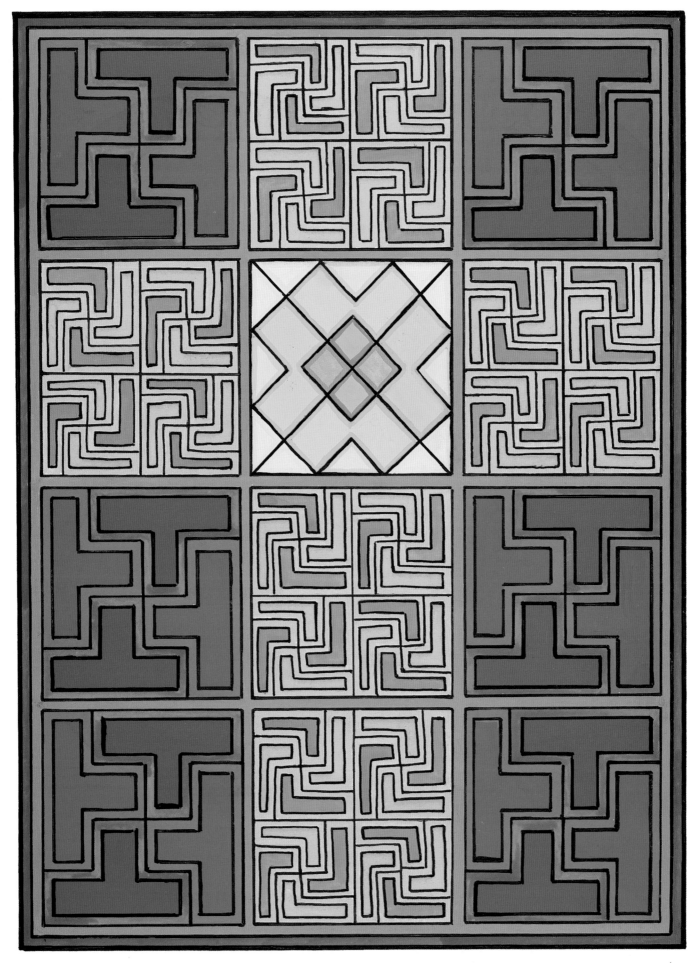

61

ZOOMORPHIC DESIGN

Zoomorphic ornament is based on animals, birds and reptiles, though in the hands of the Celtic artist nothing is as it seems: parts of different animals mingle and cats and dogs can have the bodies of birds. Anthropomorphic ornament is based on the human body, but both zoomorphic and anthropomorphic ornament may feature in the same design. You will see examples later in this book.

The 7th-century Book of Durrow is the earliest surviving manuscript to feature elaborate zoomorphic ornamentation. Its decoration depicts long-snouted animals, similar to those found on artefacts from the Anglo-Saxon Sutton Hoo burial ship.

In the Gospel books, many animal symbols are used to represent Christ. The fish is the earliest Christian symbol for Christ and the soul; the snake and the lion represent the resurrection, and the peacock signifies Christ's incorruptibility. Dogs symbolise fidelity and there is also the image of a sheepdog guiding the flock. At times, both of these were used as an allegory for a priest.

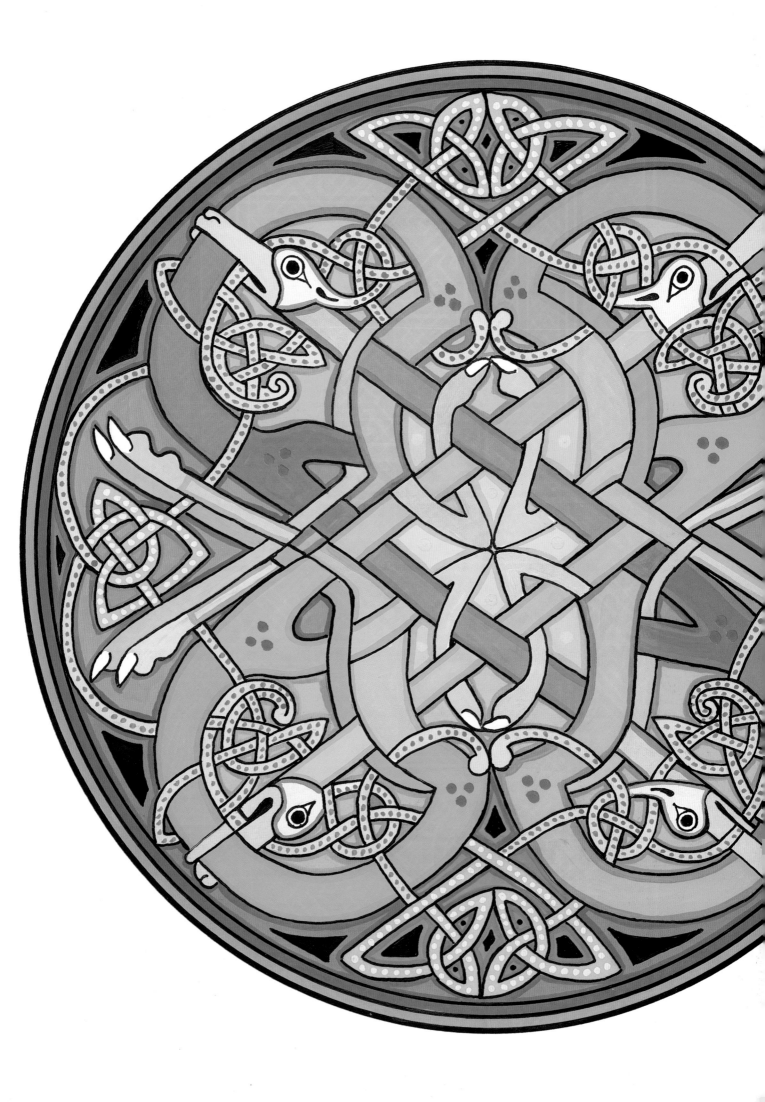

Zoomorphic ornament

Zoomorphic ornament is my favourite. The more intricate I can make it the better I like it, especially when it comes to the finishing touches and the feathers, body parts and claws need to be decorated. I spend a lot of time moving around torn-off strips of tracing paper, each featuring a dog, cat, bird or man, trying to find some new way of interlacing them. Once the idea is in place you can start to work on the details, creating the under and over movements and stretching limbs, necks and beaks to fit your design. There are numerous examples in the pages of old manuscripts, and as you gain more confidence in your abilities you may even find yourself inventing your own strange, mythical beasts!

TIP: Anthropomorphic and zoomorphic designs can be extremely intricate, if you have the patience. Experiment with sections in different colours, or even sections which feature different animal or human forms.

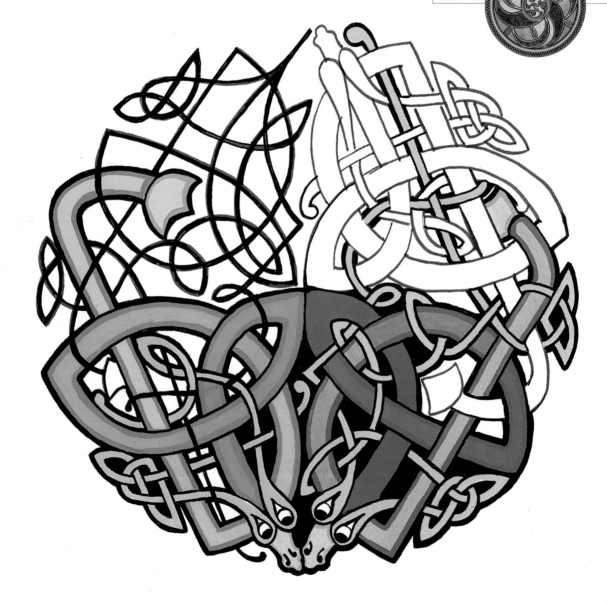

Adding animals and birds to designs makes them even more complex, as these partly-coloured designs show.

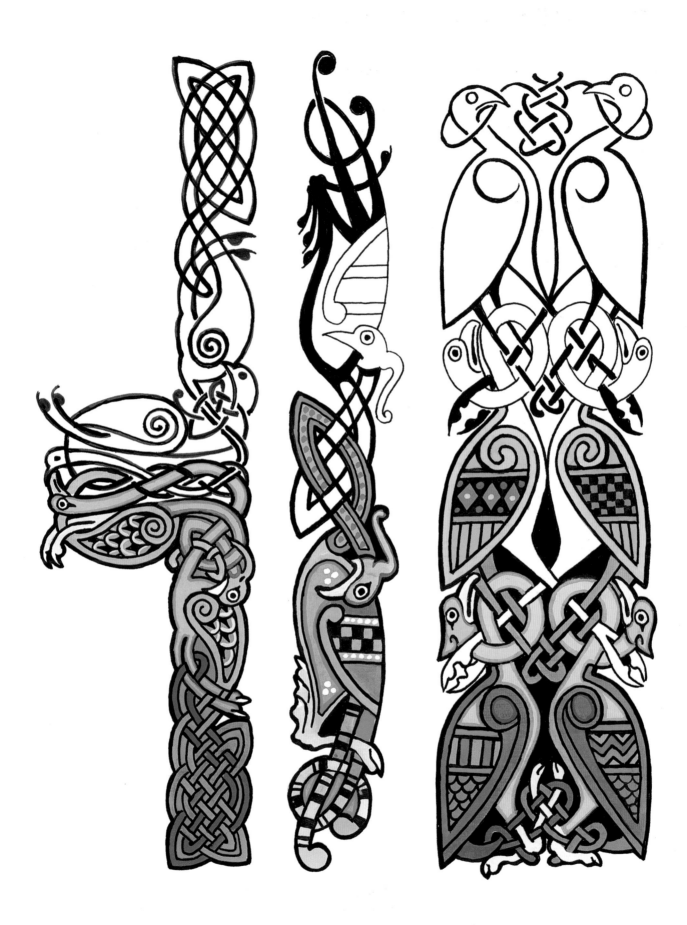

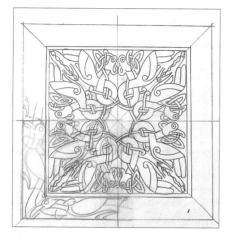

8. Trace the first corner of the border from the initial doodle.

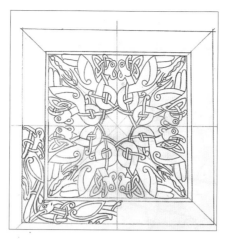

9. A quarter of the border design has been completed.

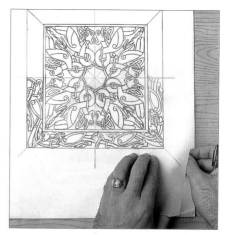

10. Build up the design by moving the doodle round and repeating it. This border design does not need adjustment where the sections join.

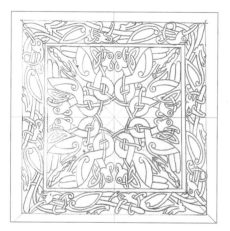

11. The finished rough design, complete with border.

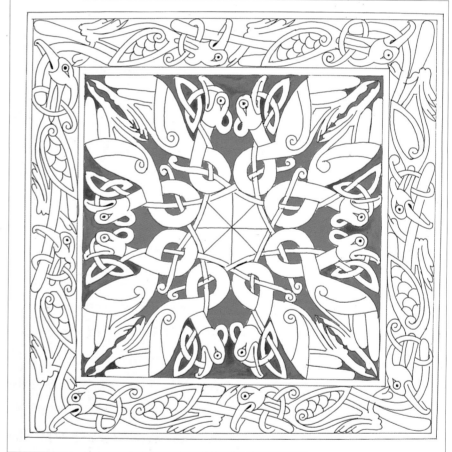

12. Start painting the design with Bengal rose and a No. 000 brush, lightening the colour with a touch of white towards the centre.

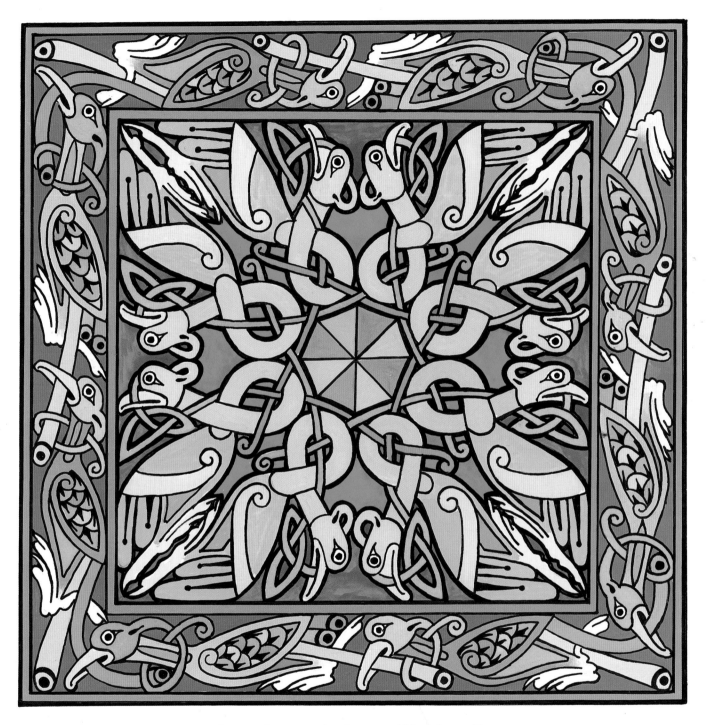

This simple zoomorphic design could be enhanced by
adding more detail to the feathers, and outlining the
neck and head with lighter or darker colours.

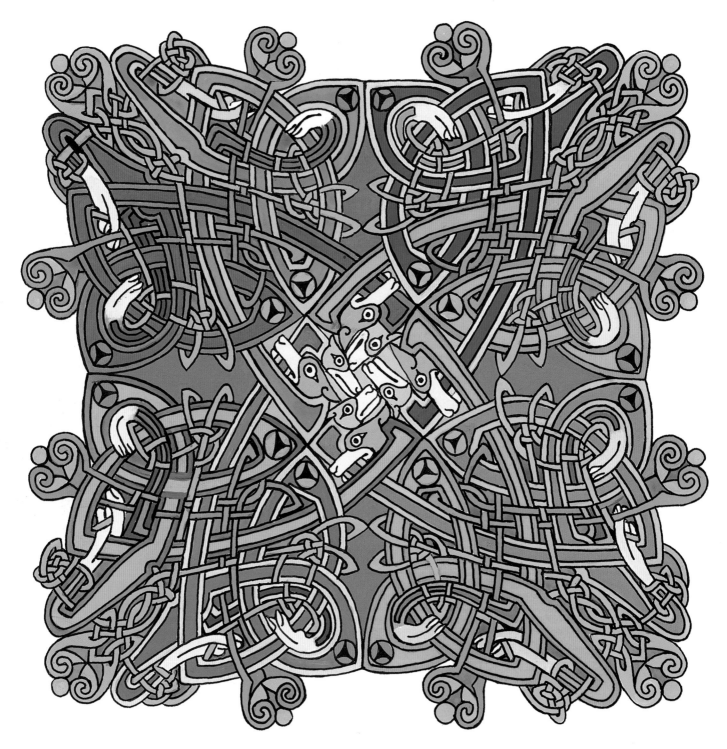

*Entwined dogs from
the Book of Kells*

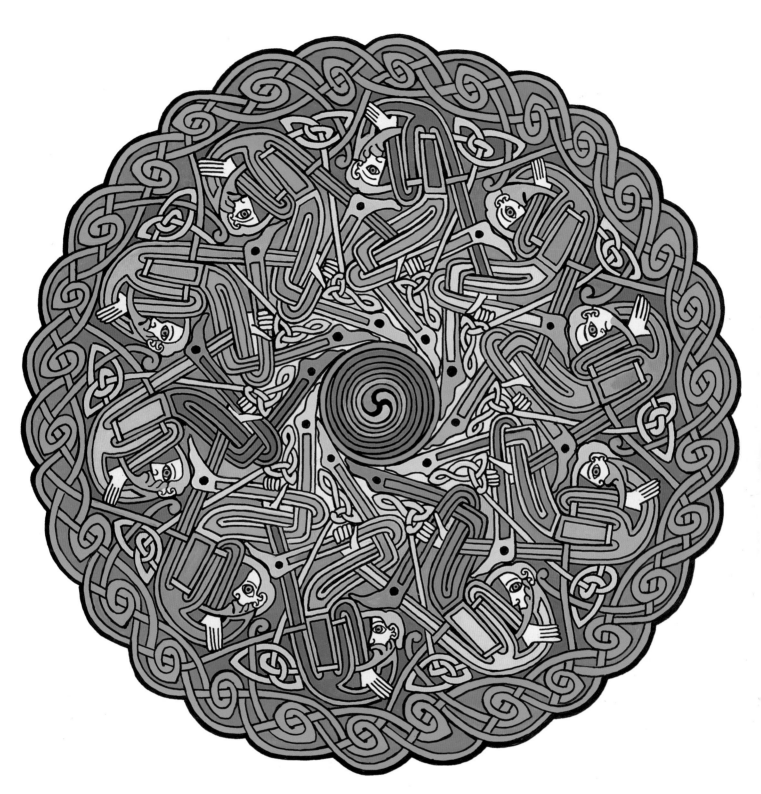

*The Eye of Sarph, above shows how
the intricacy of knotwork makes it
particularly effective with zoomorphic
or anthropomorphic design.*

Zoomorphic borders

The strange birds and animals of zoomorphic ornament are particularly effective when used as borders. Let your imagination run riot, weaving the patterns in and out of legs and beaks; intertwine claws and add fearsome-looking talons or horns; incorporate wings decorated with intricate patterns.

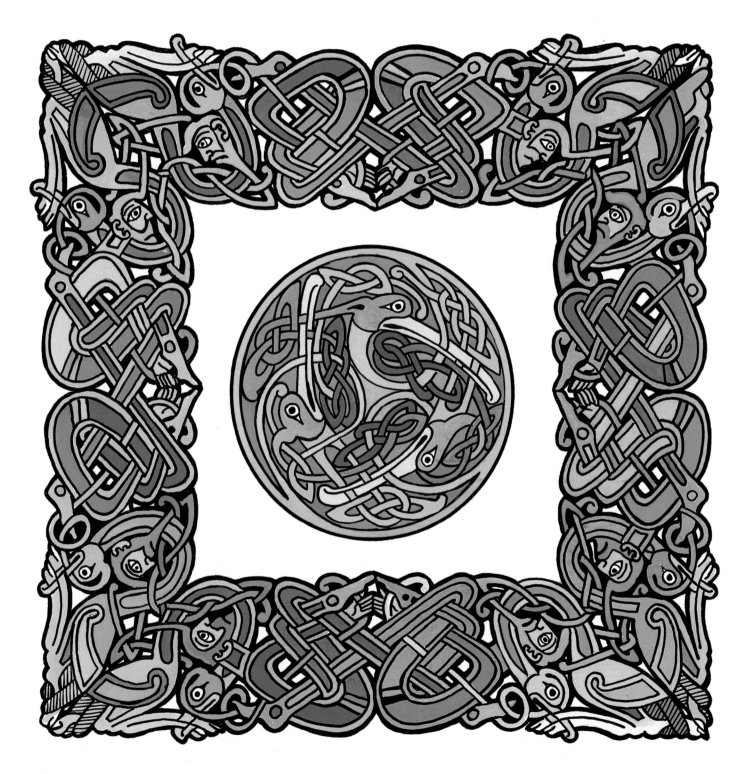

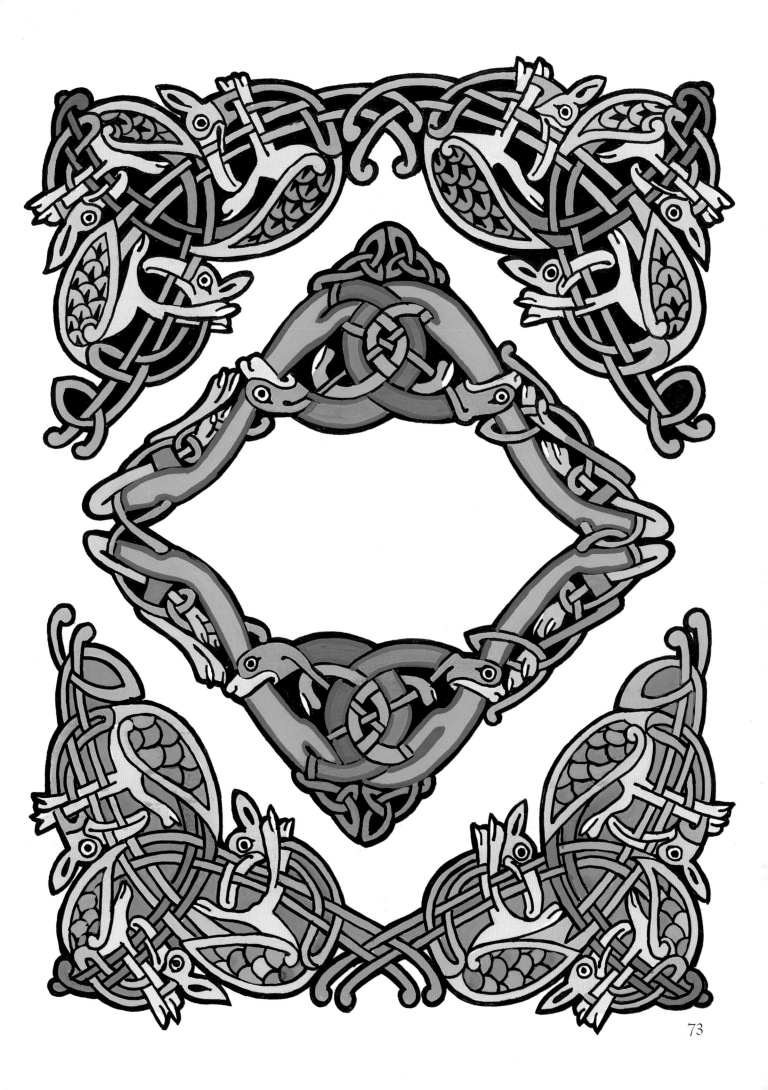

73

GALLERY

As you gain confidence in your ability, you can build on what you
have learned and branch out into designs such as the examples shown.
I know there will be many occasions in the future when you will feel
that wonderful rush of satisfaction with your efforts which will mean
that all the hair-pulling and gnashing of teeth have been worth it.

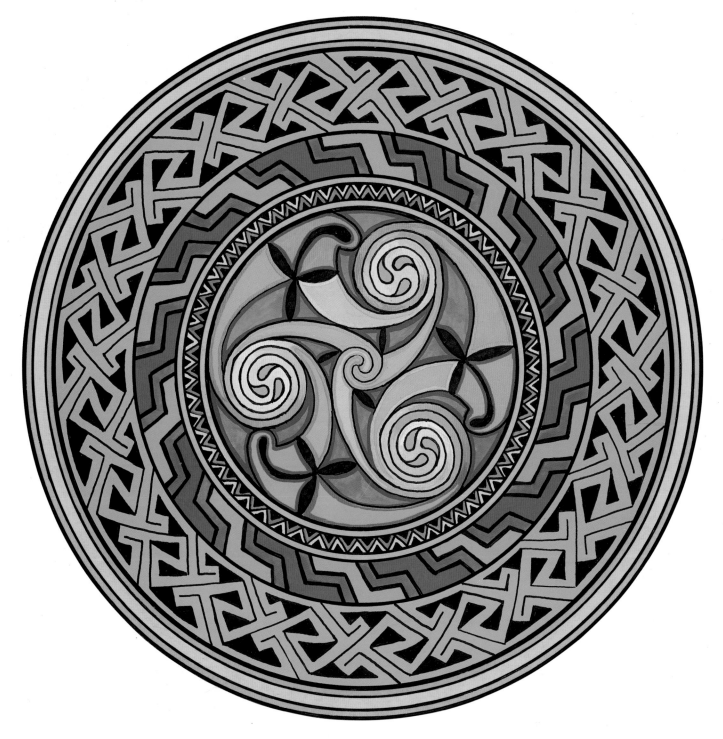

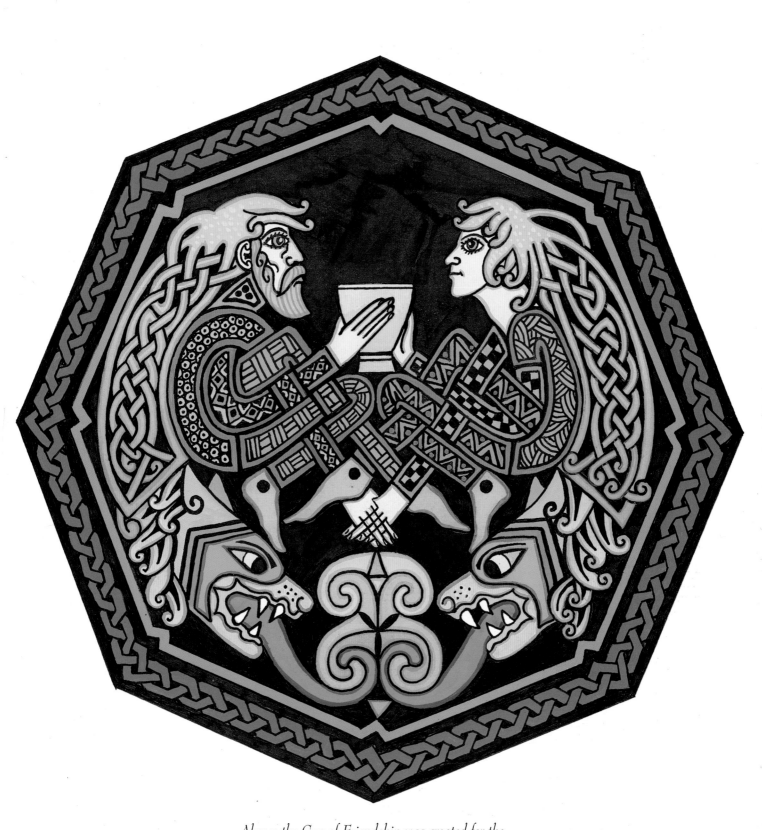

*Above: the Cup of Friendship was created for the
lid of a range of jewellery boxes*

*Left: adapted from a design in the Book of
Durrow, Path of the Initiate shows the initiate's
journey through the complex labyrinth of life to
the still centre and oneness with the creator.*

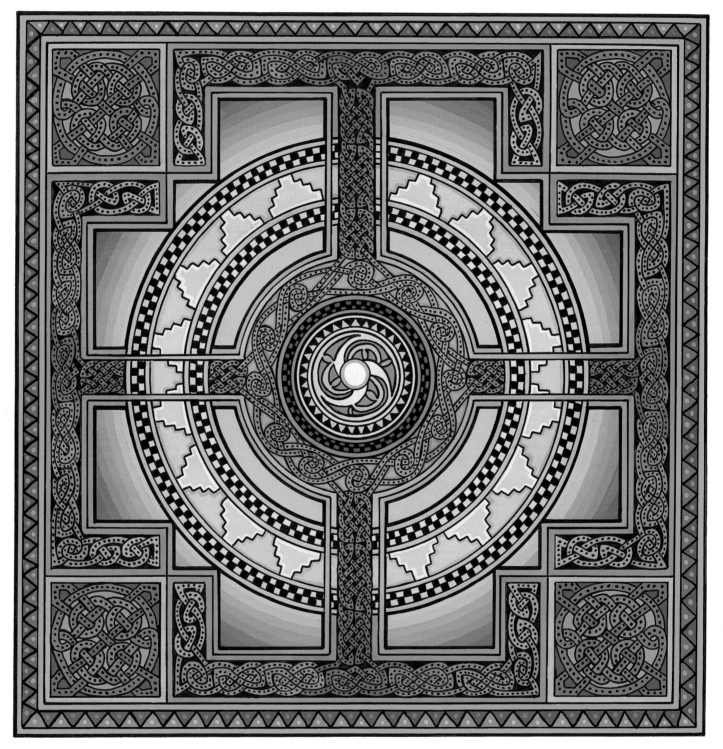

The Golden Wheel

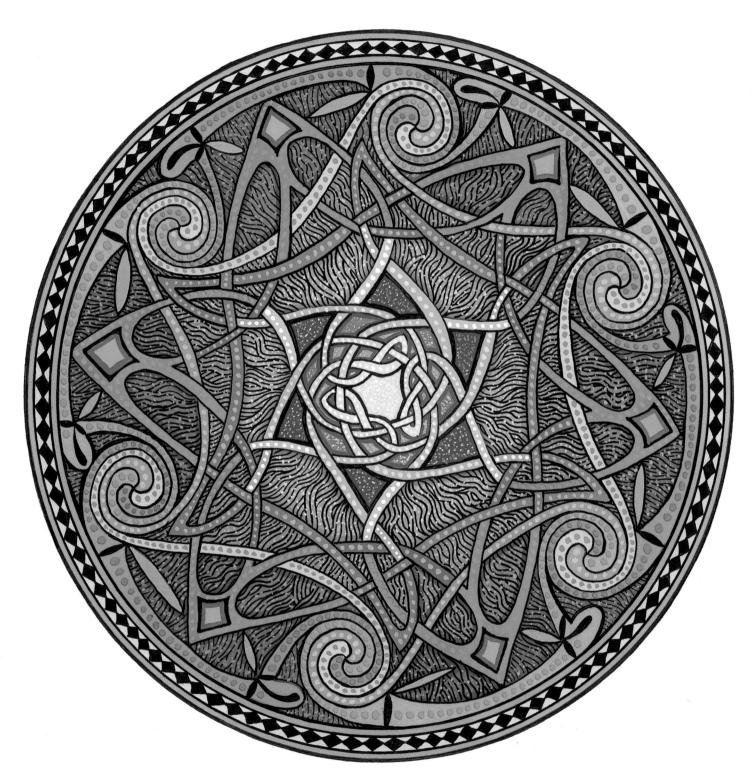

Celtic Love Knot

INDEX